Alfred Stieglitz
by Graham Clarke

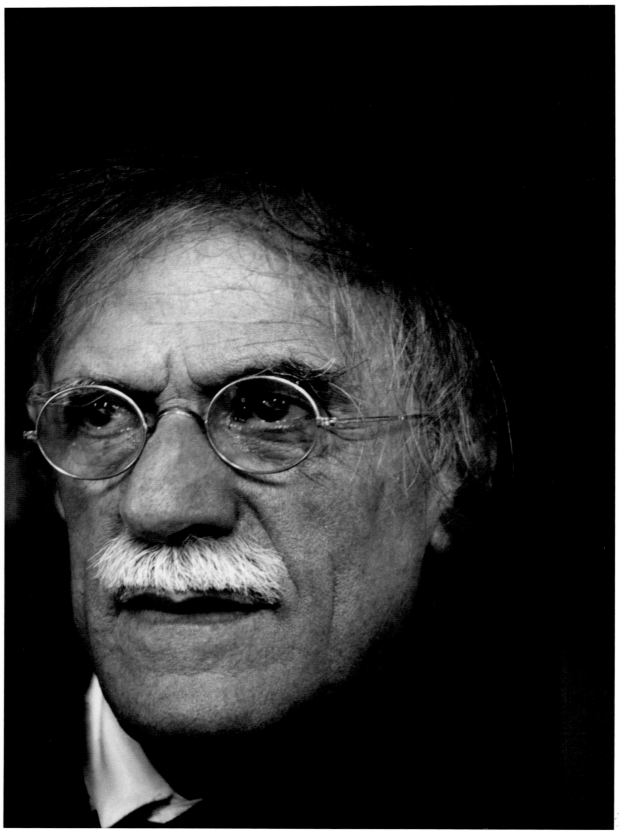

Alfred Stieglitz remains one of the most radical and significant photographers of the American tradition. His importance, however, is not limited to his significance as a photographer, for he was also an innovative publisher, gallery owner and passionate supporter of some of the most major figures in painting and photography in the first half of the twentieth century. In brief, he is a seminal figure and the founder of what we might call 'fine art' photography in the United States.

Born in Hoboken, New Jersey in 1864, Stieglitz was raised in a relatively wealthy family of German origin which was to have a profound effect on both his attitude to art and his practice of photography. The affluent background is significant for it underlies, in many ways, his subsequent terms of reference for his sense of photography and his inherent idealist aesthetic which, in its rejection of social and historical subject matter, sought a new basis for art and photography as an interpreter of the 'modern world'.

In a brief review of his career and influence, it is difficult to establish the enormous significance he has within the history of photography. For example, his status is as much based on his concern with galleries and publishing (he wrote some 260 essays and reviews) as it is on his individual photographic practice, which, for Steiglitz, were different aspects of a single philosophy. Underlying his photographic images is an approach to the subject which, whether it be New York City or Lake George, Georgia O'Keeffe or what he called his *Equivalents*, is consistently

Alfred Stieglitz by Dorothy Norman, New York, 1932

concerned with seeking the ideal image; a search that was to come into conflict with what he felt to be an increasing materialism that finally dogged his search for 'truth' from the 1880s until 1937 when he abandoned photography altogether.

In 1882 Stieglitz left the United States for Germany where, as a student in Berlin, he 'discovered' photography for himself. It was in 1883 that he purchased his first camera and began to take his first images, amongst them the extraordinary *Sunrays, Paula* (no. 01) which remains central to his *oeuvre* and is a definitive image from the period, both for its aesthetic concerns and its technical brilliance. However, if Stieglitz later declared that photography 'fascinated me, first as a passion, then as an obsession', his individual intensity was always balanced by his knowledge of the technical aspects of the medium. As a student of engineering and one who took classes in chemistry, Stieglitz always understood the camera as a 'machine' whose potential was to be realized through the creative eye of the committed photographer.

Sunrays, Paula looks towards what Stieglitz was later to call 'straight photography' and was basic to the 'Photo-Secession', an aesthetic which, as Stieglitz declared, would concern itself only with images that 'gave evidence of individuality and artistic worth'. Both were part of a fundamental reaction against the prevailing Victorian attitudes which viewed photography as a limited visual medium, or interpreted it in relation to painting, as in the work of Oscar Rejlander and Henry Peach Robinson, for example. Yet he was equally against the rapidly rising popularity of amateur photography, characterized most obviously by the introduction in 1888 of the first Kodak Brownie with its now famous marketing phrase: 'You press the button, we do the rest.' As he wrote in an 1899 essay on pictorial photography, 'Today there are recognized but three classes of photographers – the ignorant, the purely technical, and the artistic.'

Stieglitz sought a new basis for the photograph as a means of art, a pure photography related to what he felt to be the possibilities of the medium in its own right, without reference to other art forms. In this view the photographer was seen as an artist and the act of photographing a creative one which transcended the view, as proclaimed by Baudelaire, that the camera could record only a literal and surface image of the external world. Like Peter Henry Emerson in England (a leading member of the Linked Ring, an English group of artistic photographers that was to award Stieglitz his first photographic prize) the intention was to develop photography as a distinct form, which, 'by means strictly photographic', would both create and discover a new vision of the seen. Stieglitz's philosophy reflected a total commitment to the act of photographing and its endless possibilities as part of a larger search for the ideal image; the caught moment framed by the camera through the eye of the photographer as an artist, totally focused on what he viewed as a sacred act.

This commitment to photography, and its meaning as part of a new and radical modernist aesthetic made '291' (the 'Little Galleries of the Photo-Secession' that he opened on Fifth Avenue, New York in 1903) basic to his status as a central figure within the history of photography. The first of several New York galleries (to be replaced by The Intimate Gallery and, later, An American Place), such exhibition spaces were integral to his philosophy and practice as a photographer. He called them 'laboratories'. They were innovative and radical in their choice of material, and vehemently non-commercial; an aspect of Stieglitz's idealism that caused him many financial problems. At 291 the new art (both European and American) was on display. Throughout his life Stieglitz held a series of ground-breaking exhibitions which, along with his quarterly magazine *Camera Work* (published between 1903 and 1917) confirmed his status as a pivotal figure within New York at the time.

In a period which saw, in 1913, the Armory Show as the first major exhibition of modern art in America, so Stieglitz, in his own dedicated way, had already predicted and established the new terms of reference. Through 291 and the fifty issues of *Camera Work*, Stieglitz established himself as a central figure and influence in a vibrant American avant-garde. The 'Stieglitz circle' sought to make New York the modernist city, surpassing Paris in its rejection of European traditions and established cultural perspectives.

The seminal nature of Stieglitz's achievement in this period at 291, in *Camera Work* and a subsequent publication *291* (which lasted for fourteen editions), is reflected in the names of those he exhibited and published. There were exhibitions of Henri Matisse (1908), Henri Rousseau and Paul Cézanne (1910), Pablo Picasso (1911), Francis Picabia (1913), Constantin Brancusi and Georges Braque (1914). These are matched by those of the new American painters, part of a generation which sought to relate European abstraction and Cubism to their American concerns and conditions: John Marin and Marsden Hartley (1909), Arthur Dove and Max Weber (1910), and in 1916 his first exhibition of the woman who was to become his second wife, the American painter Georgia O'Keeffe. There were also important connections with writers, critics and poets: the Steins (Leo and Gertrude) whom he met in Paris, and, in particular, a group of Americans who shared Stieglitz's concern with a new modernist aesthetic – Sherwood Anderson, Hart Crane, Waldo Frank, Paul Rosenfeld and William Carlos Williams, for example.

Indeed, the status of Stieglitz is reflected in two seminal books published during his lifetime: *Port of New York* (1924) by Paul Rosenfeld and *America and Alfred Stieglitz* (1935) edited by Dorothy Norman and Waldo Frank; both homages to Stieglitz which underpinned his international status as a photographer and celebrated what Harold Clurman called

'his greatness as an artist, and his importance as a cultural force'. His influence on both American photographers and photography as a whole cannot be stressed too much. If his version of pictorial photography established a new kind of 'fine' art tradition linked to a philosophy of the camera and its modernist concerns, so he both exhibited and influenced (as well as befriended) a panoply of leading photographers of the age. There are the early associations with Alvin Langdon Coburn and Edward Steichen, for example, and his important relationships with Paul Strand and Ansel Adams, as well as his profound influence on Dorothy Norman and Eliot Porter. The achievement is enormous, especially with hindsight; it is astounding how much he has touched our notion of photography as 'a distinct medium' in its own right. As Stieglitz wrote in a 1921 catalogue for the Anderson Galleries, 'the search for truth is my obsession'.

That 'search', however, became increasingly problematic, especially after 1920. Stieglitz's aesthetic and cultural idealism was always anti-commercial and, after the demolition, in 1917, of the building on Fifth Avenue in which 291 was situated, his sense of a new art for a 'new' America reflects a developing sense of pessimism and isolation within the country. Despite its acknowledged importance, *Camera Work* closed in 1917, having declined in circulation from some 1000 subscribers in 1903 to only thirty-seven when it finished publication. What has been called his 'ceaseless energy and fixed purpose' was, ironically, having to survive in a new America that was the very opposite to what Stieglitz had imagined and from which, in its material values, he felt more and more alienated and isolated.

Much of this ambivalence is reflected in the ways he responded to the two major environments in which he lived for most of his life: New York City and the family's country retreat, Lake George in New York State. The summer and autumn would be spent at Lake George, the winter and spring in New York;

a symbolic pattern that is integral to his photographs (and letters). Both became opposite poles of his search for 'truth' and, in the imagery he produced, are basic to his aesthetic and philosophy.

New York was very much Stieglitz's city. The time he spent in Berlin and his several visits to Paris were essentially introductions to the aesthetic he sought to capture in the iconography and energy of New York: literally a 'scene' equivalent both to the modernism he embraced and the spirituality he sought in his images. From the 1890s onwards (when he started to use one of the new mobile hand-held cameras) he consistently photographed New York as an image of the new. Yet his relationship to the city was always ambivalent. Stieglitz was never an urban documentary photographer in the way that Jacob Riis and Lewis Hine were. They focused on the human condition and sought to record the poverty and cultural complexity of living conditions in the Lower East Side, especially the experiences of the recent (mainly European) immigrant groups living in the tenement blocks amongst which, ironically, Stieglitz opened his first photographic business (on Leonard Street). The density and detail of street life was, for them, basic to their perspective, as were the interiors of squalid and cramped tenement rooms integral to their documentary and sociological concerns.

Stieglitz ignored such aspects and, in his search for a spiritual America and an ideal visual form, effectively de-historicized the image in his pursuit of a transcendent or higher sense of the real. Yet his attempts were increasingly compromised by what he viewed as a crass and materialistic urban scene. In his letters, especially, he speaks of his sense of the city as empty and destructive. In 1915 he refers to it as 'an unspeakable place' but 'fascinating' and, in 1919 in a letter to Paul Strand he declares that New York, with its 'noise and dirt' is 'mad – soulless – cruelly heartless'. By 1920 it had become 'a nightmare' which,

in 1933 he again repeated in a letter to Henry Seligman: 'New York is nothing but a bad dream – a veritable nightmare.' His 'wonderful' city had become the very opposite of what he sought: its iconic significance as the centre of modernism was for him lost and empty. However, he continued to run a series of galleries in New York which exhibited new work by photographers and artists and held major exhibitions of paintings by O'Keeffe and, crucially, his own photography. Whilst the later galleries lacked the intensity of 291, in other ways they allowed him to develop his aesthetic philosophy and to create a personal space in which that philosophy (and Stieglitz) could breathe. Their names, The Intimate Gallery and An American Place (on Madison Avenue) echo their symbolic significance for him as they reflect the ways in which he could counter the negative city that surrounded him. They became ideal environments for him, partial retreats into a pure space which offered the kind of solace and fulfilment he found at Lake George. They were places where his philosophy and photography of the ideal could flourish; where, as he declared, 'every image was to be shown to its best advantage.' How ironic that one of the final portraits of Stieglitz was taken by Weegee (Arthur Fellig) and included in *Naked City* (1945) – a seminal collection of the dark, violent and underground New York which Stieglitz had always sought to avoid and rise above.

Indeed, as we view the progress of his New York work between the 1890s and the mid-1930s there is, in retrospect, an almost inexorable descent into an increasing sense of pessimism and the negative. The experience of the city seems to defeat his aesthetic philosophy and empties it of its earlier idealism and assured visual energy. Much of this early optimism was, of course, based on the novelty of New York as a new kind of city, with the skyscraper as a central aspect of this new urban spirit. Its symbolic resonance was (and is) celebrated by artists and photographers, and during Stieglitz's residence he saw the city move from its nineteenth-century appearance through

the 1900s with its rapidly changing skyline, to the 1930s
with the construction of the Rockefeller Center (no. 50);
although, unlike Lewis Hine, he ignored the Empire State
Building. Yet if he called his first volume of photographs of
the city *Picturesque Bits of New York* (1897), by 1937 his images
were vacant and defeated, although marvellously suggestive
in the feelings they evoke about Manhattan as both a visual
and lived experience.

In this context his photograph of the Flatiron (or Fuller
Building) is an exemplary Stieglitz image (no. 16). Completed
in 1902 the building was at that time, with twenty-three
storeys, the highest building in Manhattan — an obvious symbol
of the new architecture and a distinctive image of America's
difference from the traditional European urban scene. In the
early 1900s it was consistently photographed and celebrated.
Two of the most memorable images are by Alvin Langdon
Coburn and Edward Steichen — associates of Stieglitz. Yet
Stieglitz's image is basic as an example of his philosophy and
his approach to the city. His selective perspective manipulates
the scene according to a series of aesthetic principles which
underlie all of his photography. His formalist concerns
transform the building from its function as an office block into
something ethereal and effervescent, almost magical. This is
the metamorphosis he constantly sought but increasingly rarely
found. However, from the camera's position in Madison Square,
he is able to process the perspective through a series of natural
images (notably the tree) and elements (snow) which saturate
his images of Lake George.

The Flatiron is an image that reflects Stieglitz's belief in the
camera as a passport to a higher reality — an ideal form which
constitutes a sense of revelation. The image is offered as a
pure presence, so fundamental to the fine art tradition which
continues in the work of such photographers as Ansel Adams,
Edward Weston and Minor White. There is, as it were, a poetic

quality to the scene, an achieved clarity which underpins its continuing power as an image in its own right. It remains a photograph of a single moment, a unique condition, which the photographer has captured and transformed through the range and subtlety of a black-and-white print.

The image of the Flatiron was taken at street level, but from the 1900s onwards Stieglitz increasingly retreated from the city that was so central to his work and life. He rarely photographed street figures, for example, and was highly selective of what he chose to focus upon. In many of his photographs he empties the city of its human presence and energy and seeks a view of the city as a series of abstract forms which echo his concern with the spiritual. We should remember how indicative it was that in 1912 he published sections of Wassily Kandinsky's *The Spiritual in Art* in *Camera Work*.

In the 1900s Stieglitz virtually abandoned street level and began to photograph Manhattan either from the fifth storey of his 291 gallery (no. 30) or, as in *The City of Ambition* (no. 22), from Brooklyn and the East River. The long view becomes dominant, as does the high view. When he and O'Keeffe moved into the Shelton Hotel in mid-town Manhattan, Stieglitz started to photograph the city from their apartment high above Lexington Avenue (no. 50). These images view the city from a protected distance. They transform New York into what Lewis Mumford called 'a ghost city'. In the images from the 1930s there are no human figures – New York has been emptied of activity and, from his position behind the windows of his Shelton apartment, Stieglitz seems to have become almost a prisoner of his own idealism.

If Stieglitz made New York central to his work, his response must be viewed as part of a larger view of all aspects of his experience and photography. As he wrote in 1916, his portraits, buildings, landscapes and interiors were 'all interrelated' and

in this context Georgia O'Keeffe (whom he met in 1916) is a key figure. They had an often difficult and tempestuous relationship and, in the later years, O'Keeffe would retreat to her own locale in New Mexico just as Stieglitz would go to Lake George. Yet O'Keeffe remained one of his most constant subjects, an identity (and enigma) on which he turned his camera as part of a complex and intimate relationship. Beginning in 1917 (when he was still married to his first wife, Emmeline) Stieglitz took some 500 images of O'Keeffe – one of the most extensive and inspired attempts to frame a single body (and personality) through photography (nos 32–34, 36, 55).

In their totality the images constitute a labour of love and dedication, a tribute to the singular nature of their subject. But they remain problematic and, like the images of New York, hover between Stieglitz's continuing attempts to fulfil his sense of what the photograph could achieve and the ambivalent nature of the subject. Stieglitz's attempts (and demands) to photograph her and his dominance over and insistence on the 'act' of her being photographed was met equally by O'Keeffe's independence and, of course, her own status as a major female American painter. The images remain, however, difficult; part of a serial biography in which the subject is represented but never, ultimately, defined.

Indeed, O'Keeffe resisted Stieglitz's attempts to define her, just as she resisted (for all his support of her painting) his attempts to influence her art. And yet they remain remarkably radical images both in relation to the nature of the photographic portrait and how an individual is to be represented. There is no definitive image of O'Keeffe. Her body is viewed in parts: hands, breasts; as nude, as a series of personae (wife, artist, partner, lover), and as an individual at once enigmatic, ponderous, distant and questioning. In the end the images express the problematic nature of trying to photograph an individual personality, and reveal as much about the way Stieglitz sought to frame his

subject matter as what he had learned about the nature of portraiture from the Cubist portraits by Picasso and Braque that he had seen in Paris and published in *Camera Work*.

Although the images of O'Keeffe remain at the apex of his portrait photography, they need to be viewed equally as part of a larger concern with the female nude, and of those personalities associated with his New York circle, notably John Marin, Waldo Frank and Arthur G. Dove (no. 29), for example — images radical as much for their interpretation of the single figure as for the way they broke with photographic convention (Stieglitz had published the then relatively unconventional nineteenth-century portraits of David Octavius Hill and Robert Adamson in *Camera Work*). Many of the portraits (and nude studies) were taken in the open air and achieve a remarkably close and intimate relationship with the subject. Like so much of what Stieglitz did, they remain ground-breaking in their approach. Often as close to the subject as possible, they probe the individual's identity, unconcerned with social status and intent on the way a single image can achieve both a complex and complete summation of the personality.

Yet it is perhaps the images from Lake George (nos 37–39, 43, 52–53) that remain the most definitive examples of Stieglitz's sense of pure photography and its possibility as a fine art. Lake George was for him both a sacred place and a personal sanctum, and he sought to capture its natural possibilities throughout his lifetime. At Lake George he could view nature as part of an underlying spiritual condition. The images become visual meditations, which in their atmospheric formal qualities (often extraordinarily abstract) represent both a creative and emotional sense of the mystery of the world. The eye, via the camera, seeks what was, for Stieglitz, a higher reality, informed by German philosophy as well as the American transcendentalism of Ralph Waldo Emerson and Henry David Thoreau.

The series he called *Equivalents* (nos 45–46), which he began in the early 1920s, is perhaps the epitome of this search by what Dorothy Norman called 'an American seer'. These are distinct from the natural images of trees and hills, snow and grass, and are based instead on studies of clouds. They are at once dense and intense, their small size almost suggestive of the focused construction by which Stieglitz sought to record what he felt at the moment. Indeed the emotional quality gives way to an abstract quality whereby the epitome of the Stieglitz project is achieved. Displacing any sense of perspective or reference to a literal world, the eye looks *into* rather than *at* the images as part of a mysterious otherness; a series of visual epiphanies. The original subject has been transformed through the creative eye of the photographer and by the camera as a creative machine.

Stieglitz called them 'beautiful', which for him was as much an emotional as an aesthetic term of meaning. The *Equivalents*, like the *Songs of the Sky* series before them (no. 44), reflect as they embody his philosophy as both a photographer and an artist. They emanate a vital sense of presence, and the exhibitions that he held of them in the 1920s resonate against the increasingly empty images of New York, culminating in the dead urban prospects he made from his apartment in the Shelton Hotel. Their concern with the abstract underlines their radical status and lays stress on the camera as part of a philosophical as well as a creative process. As he noted of them, 'I know I have done something that has never been done.' As 'songs of the sky' they were 'documents of eternal relationship'; definitive images of the pure photography he always wanted to achieve.

In this search for the pure image, developing and printing were crucial to the photographic process. If he sought the formal possibilities of the subject so his insistence on the technical was essential to his approach. Indeed the darkroom was, in effect, the summation of the whole effort. Stieglitz would spend hours in the darkroom refining the image he sought, and discarding

print after print in his search for the ideal form he wanted. As part of a fine art tradition the photograph, in this sense, was as much an object as it was an image: a limited edition which underscored the intense relationship between the process and photographer, an achieved visual purity that was continued in the work of such figures as Ansel Adams and Minor White. Just as they refuted colour in favour of black and white, so they sought to transform a literal world in which the photographic image is not so much a record of the scene as a revelation of the seen.

The sum of Stieglitz's work represents a philosophy in action. If many of his images have become iconic in their influence and significance, they retain a wonderful freshness and resonance; testaments to the wonders of seeing over merely looking. His stature remains enormous, not just as an artist, but also in terms of his influence on later photographers, on the 'tradition' of abstraction and fine art photography, the significance of the gallery, and on photography as a medium in its own right; a medium to which he was totally committed.

Alfred Stieglitz was never a documentary photographer. Indeed he ignored (and avoided) the social and economic implications of the scenes he photographed in his search for an assumed higher reality. His stress on composition and the formal qualities of a photographic image are part of his idealism. His lack, as it were, of an historical perspective is part of that aesthetic. And yet in many ways that is the very nub of his intention. His art is the distillation of his encounters with the world around him. As he wrote in 1903, 'The Secessionist lays no claim to infallibility, nor does he pin his faith to any creed, but he demands the right to work out his own photographic salvation.' In this, Stieglitz was brilliantly successful.

01 1889 | Sunrays, Paula.

A definitive early image by Stieglitz distinguished by its technical brilliance, especially in its concern with patterns of light and shadow. The approach, however, lays stress on its narrative elements. Paula is writing (not reading) and dressed to go out into the city streets. The way the image questions nineteenth-century stereotypes of both women and photography is intimated by the bird cage on the wall and the series of photographs which act as a statement of both the individual and society, and the nature of photography itself. The photographs include images of Stieglitz and Paula, of Paula in bed, and of landscapes which look to the later *Equivalents* (nos 45–46). The photograph constitutes a veritable manifesto of Stieglitz's aesthetic concerns and later photographic developments.

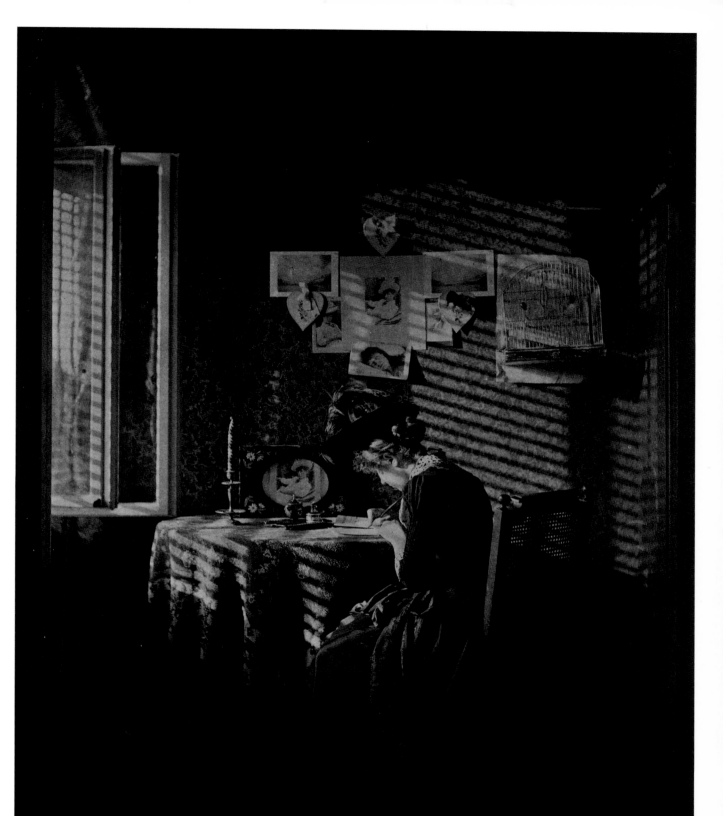

1890 | At Biarritz.

A brilliant formalist study characterized by its range of black and white tones. The sense of stillness is redolent of much American Luminist painting, especially the work of Fitz Hugh Lane. There is, however, a quizzical and enigmatic quality to the scene which suggests the later work of Henri Cartier-Bresson. Although dominated by its linear structure, the horizontal composition is balanced by a series of distinctive details. There is no sense of depth and yet the image demands to be endlessly looked at. Typical of Stieglitz, it offers a deceptive quietism.

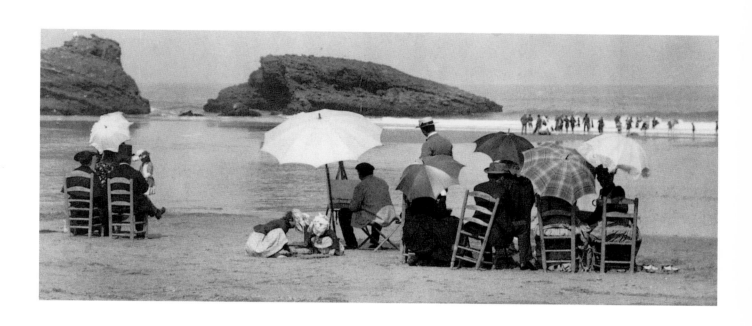

1893 Five Points.

A photograph of Fineberg's East-Side store in the notorious Five Points area of New York. As Stieglitz noted of this period: 'From 1893 to 1895 I often walked the streets of New York downtown, near the East River, taking my hand camera with me. I wandered around the Tombs, the old Post Office, Five Points. I loathed the dirty streets, yet I was fascinated. I wanted to photograph everything I saw.'

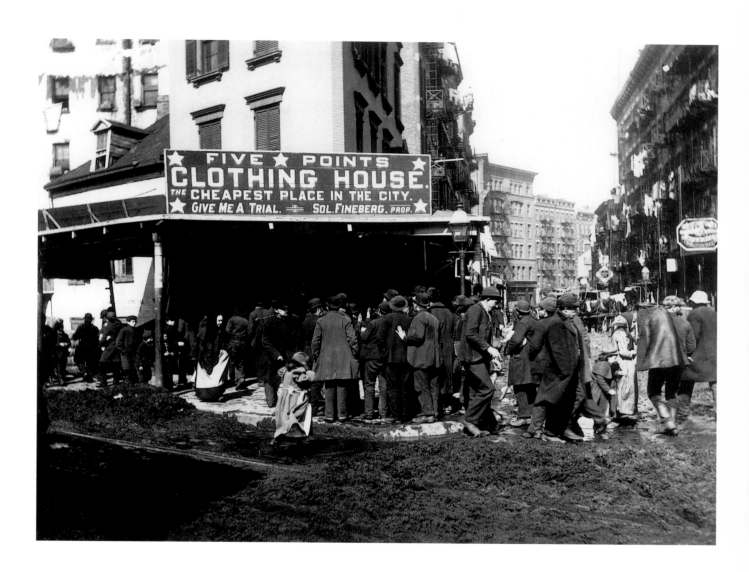

04 1893 The Terminal.

A New York image taken in Lower Manhattan in front of the (now demolished) General Post Office building – a tram driver waters his horses at the terminal of the Harlem streetcar. As Stieglitz stated, 'There seemed to be something closely related to my deepest feeling in what I saw, and I decided to photograph what was within me.' Note the inclusion of a broom and the passing male figure in the background; potentially disparate details which detract from the 'unity' Stieglitz attempts to photograph. Compare with the figure and broom in *Spring Showers* (no. 14).

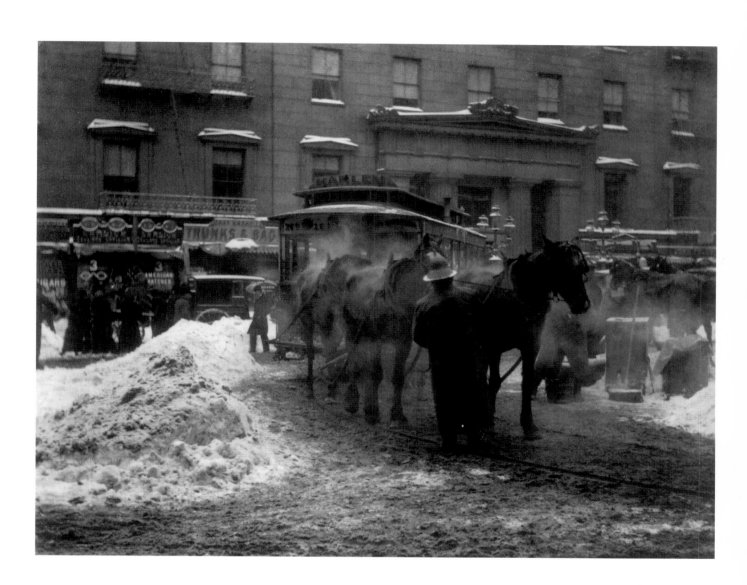

1893 Winter, Fifth Avenue.

Stieglitz photographed this image on the corner of Fifth Avenue and 35th Street and claimed that he waited in the freezing cold for three hours before the moment was 'correct'. He used a borrowed hand camera, which gave him a new sense of mobility and freedom for his photographs of New York. When his friend, Sadakichi Hartmann, saw the image he declared that it 'reminds me of nothing else'.

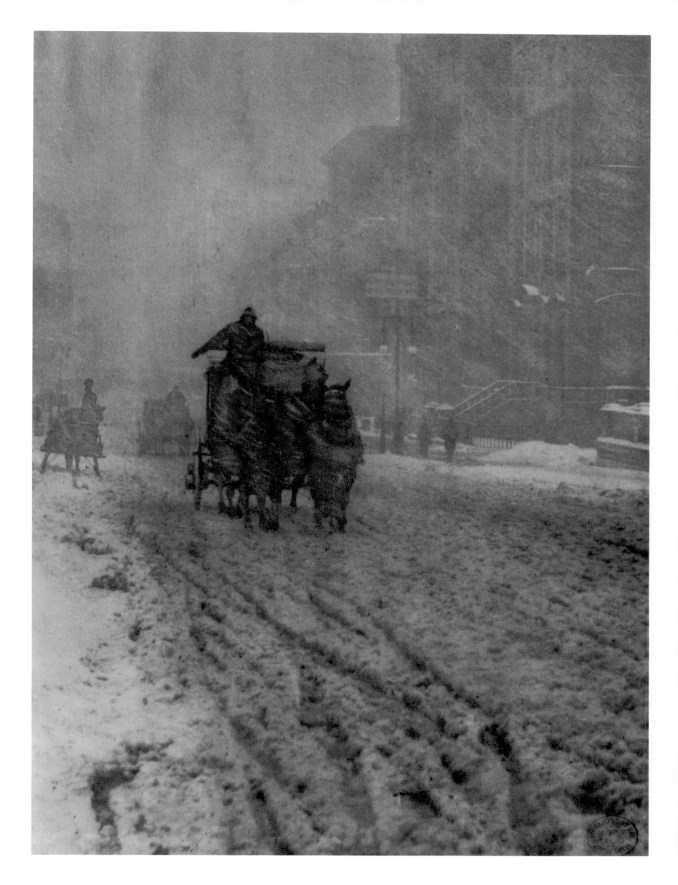

1894 | Scurrying Home.

One of a number of early photographs taken in Europe, in this case
Katwijk aan Zee in the Netherlands. Stieglitz resists a picturesque response,
characteristic of some of his other European images, and creates a distinctive
sense of the scene through the radical composition and the extensive and
textured foreground, through which we view the figures 'scurrying home'.

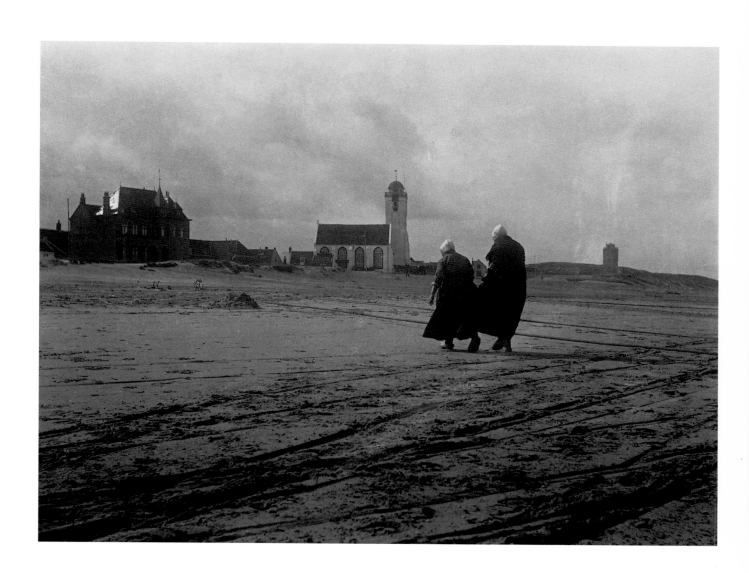

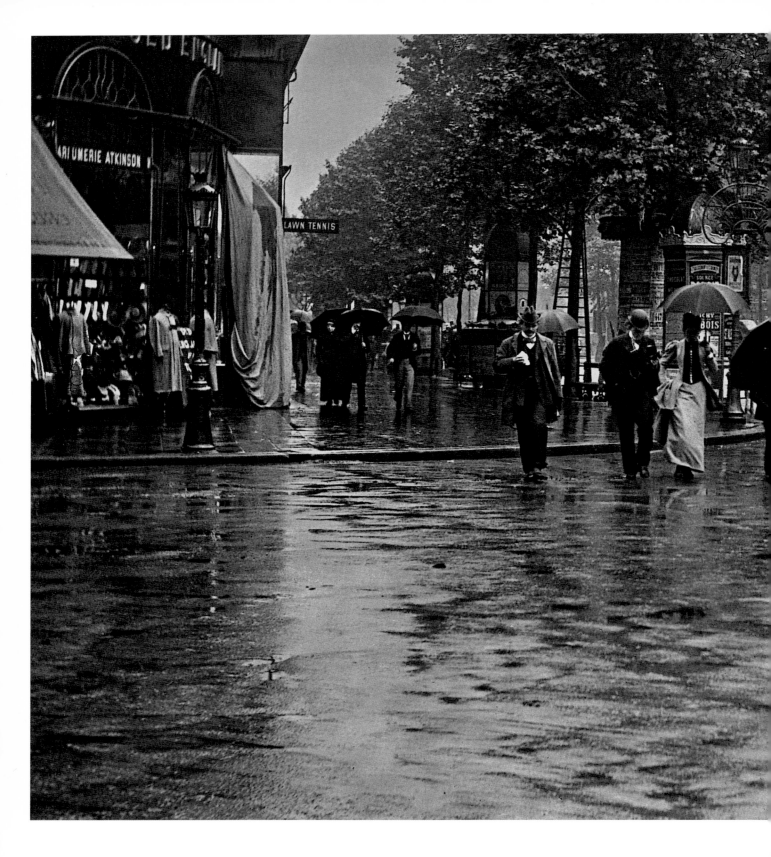

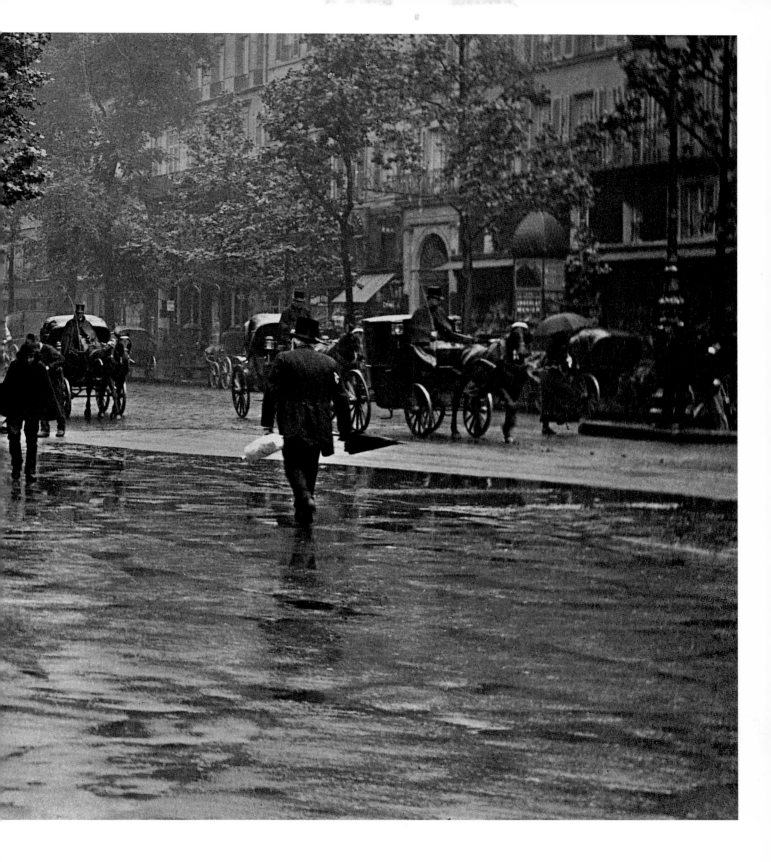

07 *previous page*	1894	A Wet Day on the Boulevard, Paris.

A photograph of the Old England Shop on the Boulevard des Capucines taken during Stieglitz's visit to Paris in 1894. Although he noted that he found, at the time, Parisian photography to be 'rather mediocre', he thought Paris to be 'full of fascination and beauty'. The image reflects Stieglitz's love of water but it also lays emphasis on his predictable urban spaces. In contrast to Eugène Atget and Jacob Riis, for example, Stieglitz photographed the open boulevards and avenues, not the alleys and passageways we find in their work.

08	1894	A Street in Bellagio, Italy.

Although some of Stieglitz's images of Italy remain within a tourist perspective, this image, with its concentrated focus on the relation between surface and light, is comparable to the work of Frederick Evans. In typical terms, one's eye is led upwards towards the area of white: the light which is the very essence of photography.

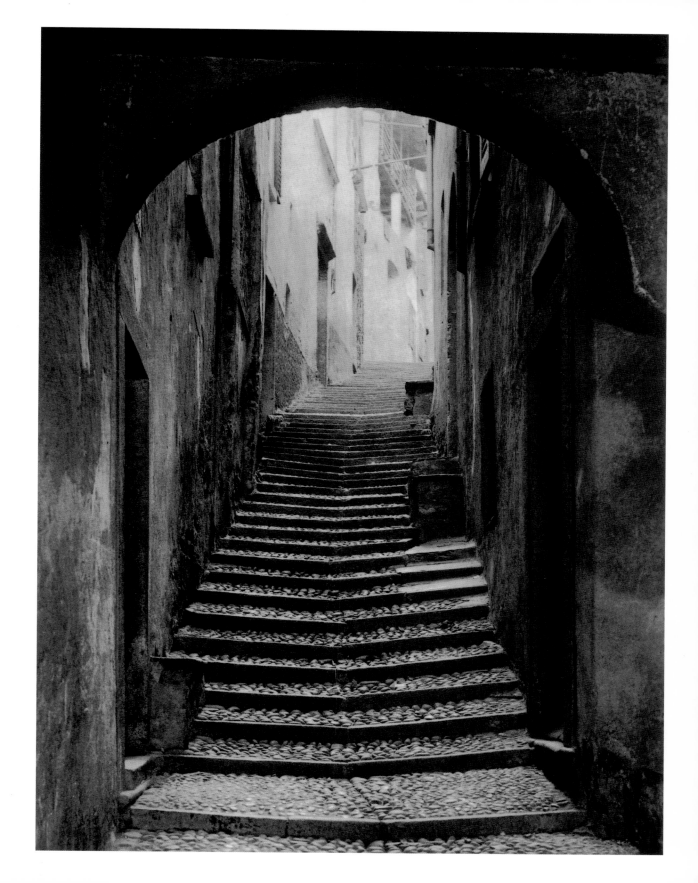

09 1894 Stones of Venice, Chioggia.

A photograph from Stieglitz's European tour of 1894, this is remarkable for its sense of composition and the formalist approach to the subject. It achieves a serene balance between the specificity of place and the claims of a larger sense of unity. It shows how so much of Stieglitz's later approach was already established by the 1890s.

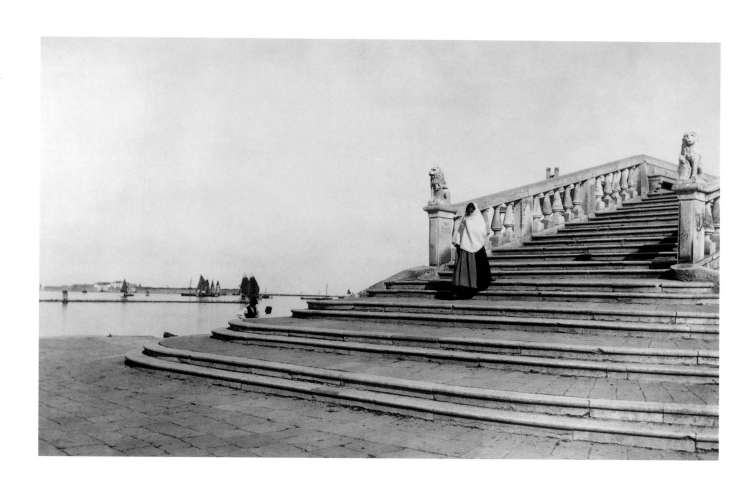

10 1896 Reflections, Night.

One of Stieglitz's first night pictures, which would go on to constitute a major area of his work in New York. Technically outstanding, this image can be viewed in relation to what he wrote in 1899: 'Every phase of light and atmosphere is studied from its artistic point of view, and as a result we have the beautiful night pictures.'

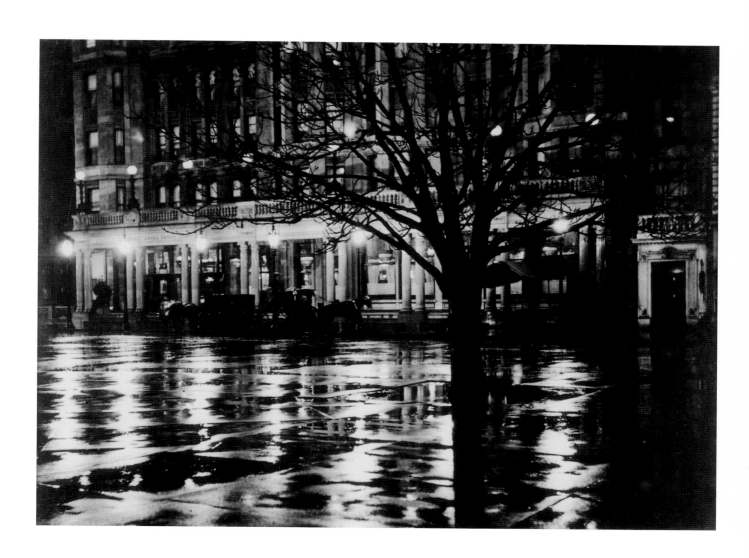

| 11 | 1896 | The Subway Entrance.

During the 1890s and early 1900s Stieglitz made some of his most significant images of New York. His new hand-held camera offered a new mobility. This image, based on one of the new subway entrances in Lower Manhattan, transforms a functional and new urban icon into a study of subtle tonal variations and structural oppositions. While many saw the subway as part of a brutal modernity, here it reflects the title of Stieglitz's 1897 volume, *Picturesque Bits of New York*.

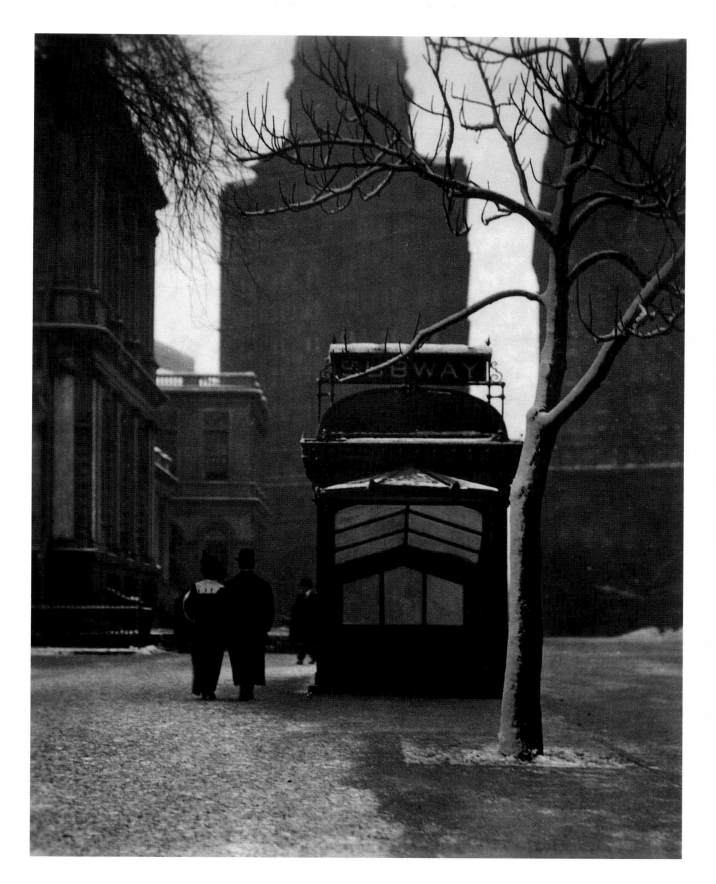

12 1898 Avenue of Trees in the Snow.

Stieglitz made snow (and water) basic to his photographs. As he said: 'I have always loved snow, fog, rain, deserted streets. All seemed attuned to my feeling about life in the early 1890s.' The image was taken in New York.

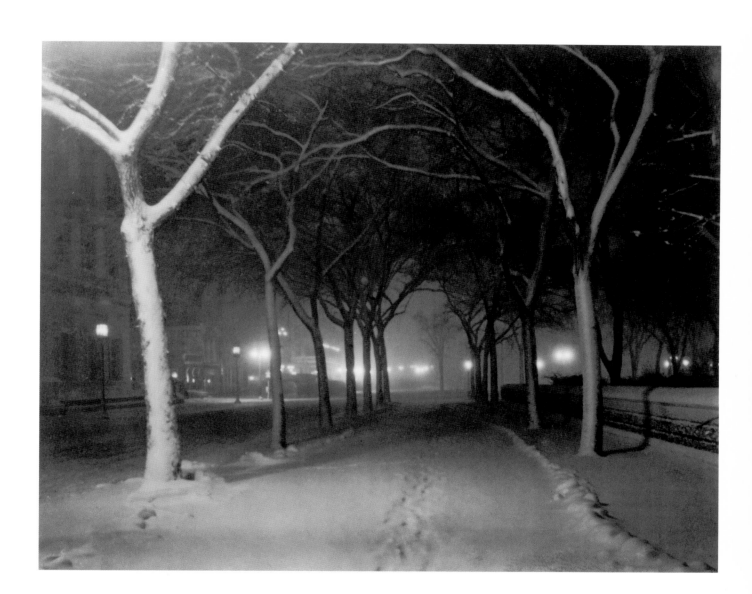

13 1900/01 The Street, Design for a Poster.

Also known as *The Street, Winter*, this image contrasts with its title. This is not just a street, but Fifth Avenue (near the 291 gallery), and the idea of this being a design for a poster runs counter to Stieglitz's entire aesthetic. His non-commercial principles are evoked through the subtle tones and shapes that he creates from a brash materialistic environment. Just as he never took a 'snapshot' so he never designed a 'poster'.

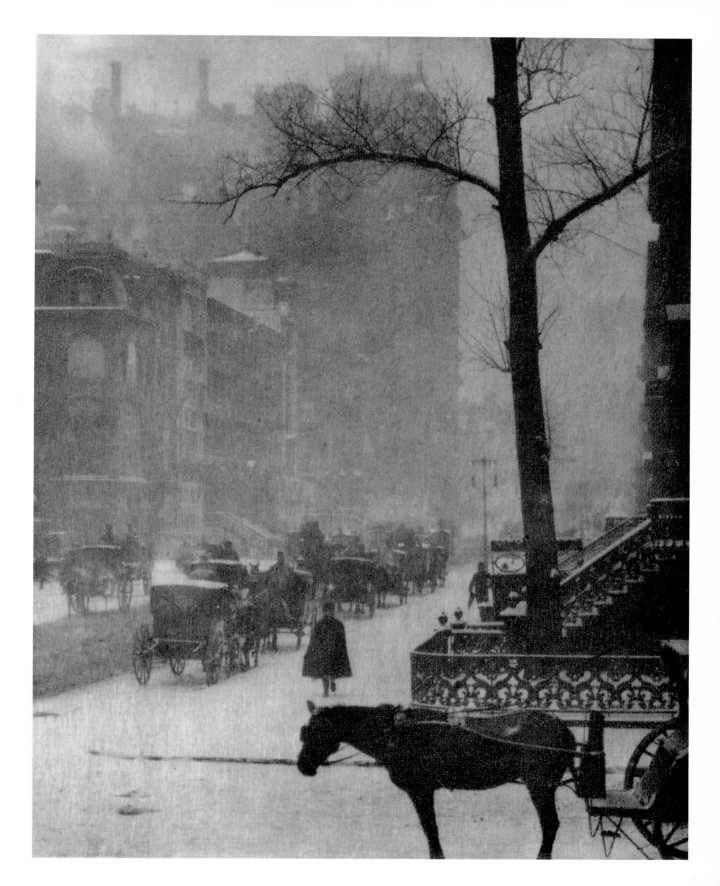

14 1901 Spring Showers.

This photograph has been cropped in order to emphasize the verticality of the subject – a tree on the edge of Madison Square, close to where the 291 gallery was established. This image has a Japanese quality about it, reflected in its pure and simple approach to the scene. The title has obvious symbolic undertones, notably in what 'spring' and 'showers' suggest, although any sense of optimism is qualified by the iron frame that surrounds the tree.

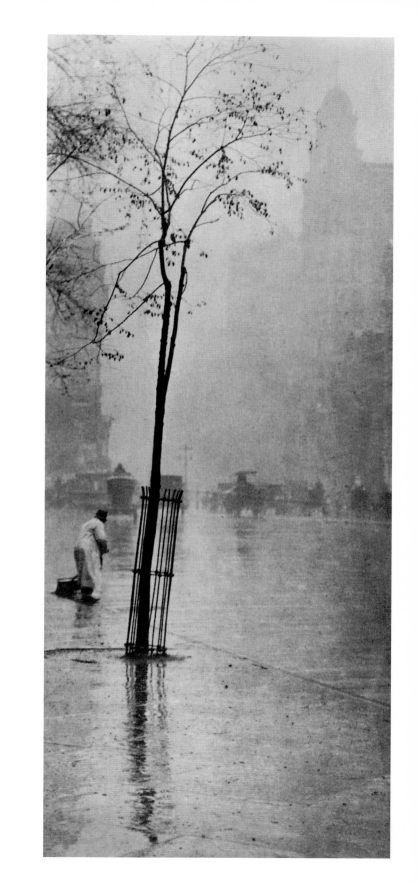

15 1902/03 The Hand of Man.

Stieglitz said of this image that it was meant to reflect the 'pictorial possibilities of the commonplace'. Based on the New York railway yards, its title suggests an ironic and ambivalent response to the subject. Stieglitz sought the pure, the clean and the clear. This 'hand of man' has produced an America covered in grime and the pollution of a new industrial order.

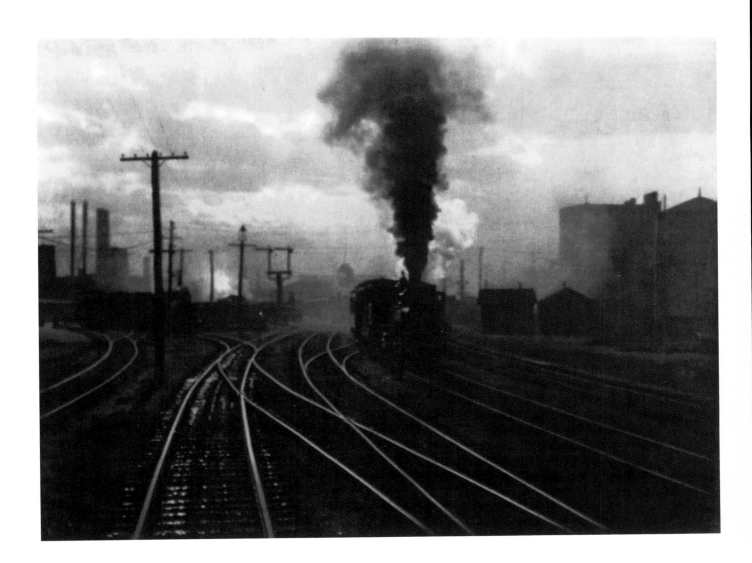

| 16 | 1903 | The Flatiron. |

A definitive Stieglitz image, this is the Fuller Building (or Flatiron) at the triangular juncture of Broadway and Fifth Avenue at Madison Square. Repeatedly photographed, Stieglitz's response is basic to his sense of both the city and photography. As he wrote, 'I stood spellbound as I saw that building in that storm' because 'that particular snowy day, with the streets of Madison Square all covered with snow, fresh snow, I suddenly saw the Flatiron building as I had never seen it before. It looked … as if it were moving toward me like the bow of a monster ocean steamer, a picture of the new America which was still in the making.' Stieglitz later declared that the building was: 'to America what the Parthenon was to Greece', although he equally noted that he found it 'unattractive' and that 'there was a certain gloom about it'.

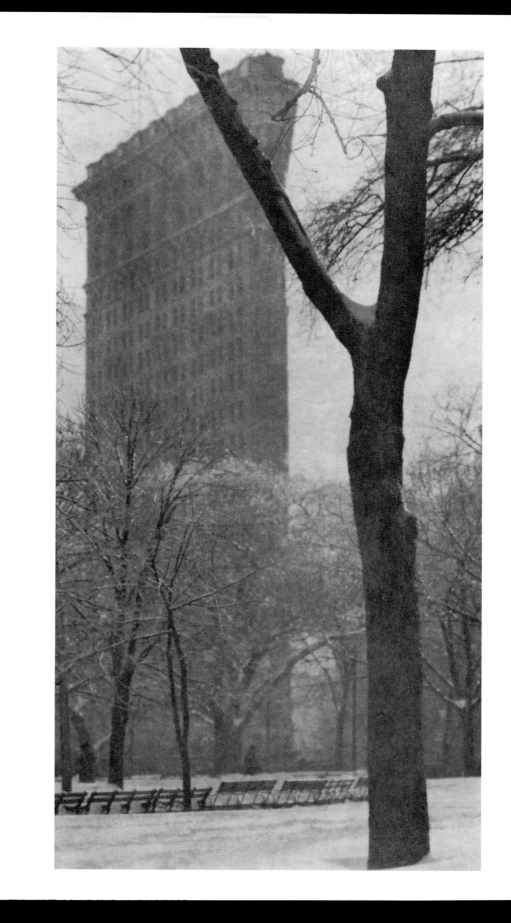

17 1904 | Going to the Post, Morris Park.

Also known as *Going to the Start*, Stieglitz published this image in *Camera Work* in 1905. The somewhat unusual subject matter (a racecourse) is matched by his approach to the scene. The movement of the horses and riders on the left and the crowd in the lower half of the image are balanced by the formal geometry Stieglitz 'discovers' in the moment: the dominant central vertical post and its horizontal equivalent, the black of the bottom half against the lighter tones of the top half. Stieglitz has created a unified image from the 'chaos' of a single moment.

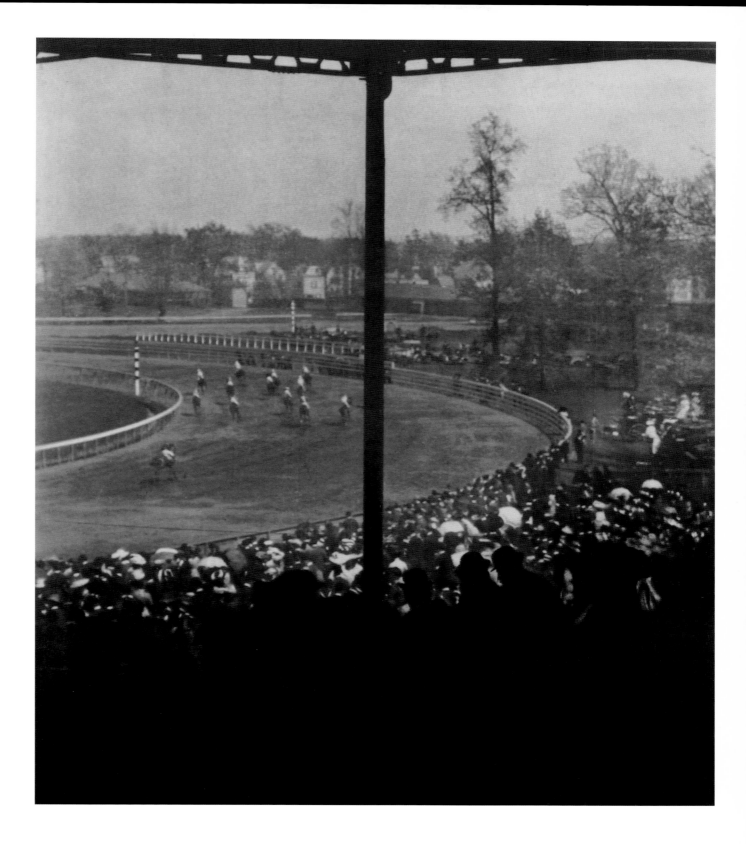

| 18 | 1904 | Snapshot From My Window, Berlin. |

Published in *Camera Work* alongside *Snapshot From My Window, New York* (no. 21) this establishes one of the central poles of Stieglitz's photographic experience. He was of German origin, but he also began his photographic career in Berlin when a student in the 1880s and 1890s. This is essentially a homage to the city and to nineteenth-century Europe, for example the Parisian street scenes of Gustave Caillebotte. The cathedral, the buildings in the background, the carriage and the trees establish a distinctive 'European' atmosphere.

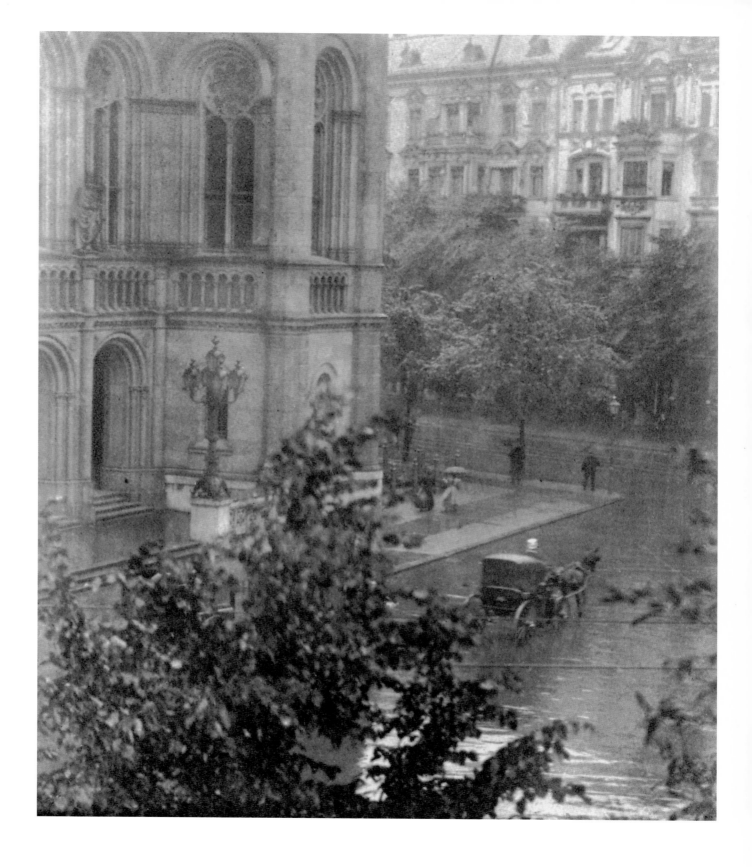

19 1907 The Steerage.

Taken on board the SS *Wilhelm* on its way to Europe, this remains one of
Stieglitz's definitive images. From his position on the first class deck he
looks down on the steerage passengers. Despite the poignancy of the scene,
Stieglitz recalled his response as follows: 'A round straw hat, the funnel
leaning left, the stairway leaning right, the white draw-bridge with its
railings made of circular chains – white suspenders crossing the back of a
man in the steerage below, round shapes of iron machinery, a mast cutting
into the sky, making a triangular shape. I stood spellbound for a while,
looking and looking and still looking? I saw shapes related to each other.
I saw a picture of shapes and underlying that the feeling I had about life.'

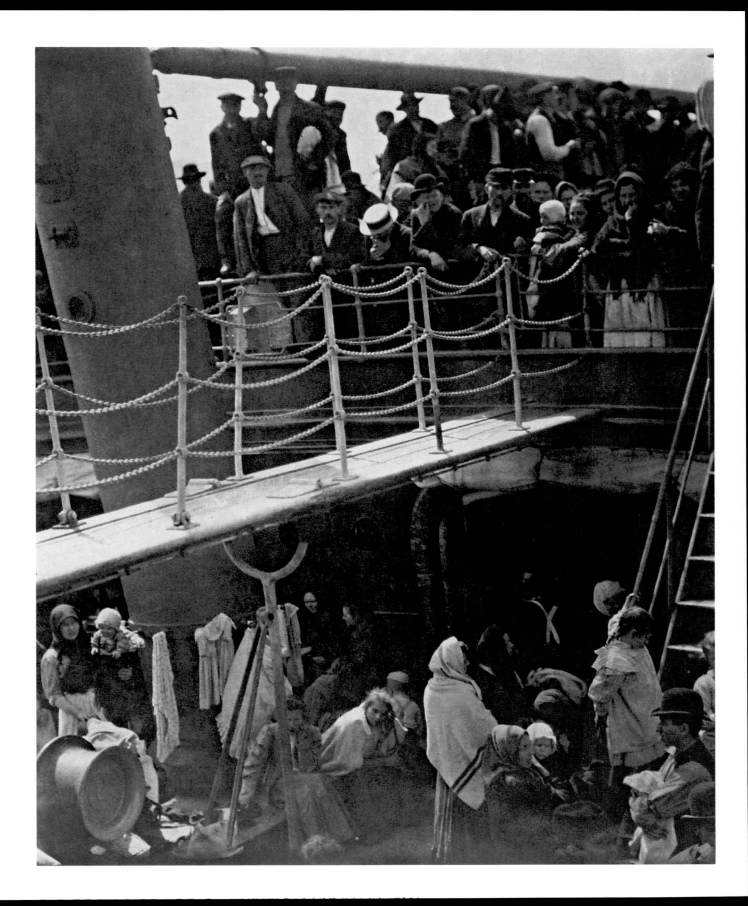

1907 Self-Portrait.

A relatively early self-portrait which is reminiscent of both Steichen and Coburn in its approach to the presence of the figure. The image emanates a brooding and mysterious quality which, in turn, recalls Rembrandt's self-portraits in its subtle use of light and dark. Stieglitz depicts himself as an enigmatic figure quite different from the frail man seen in later portraits by Dorothy Norman (see page 2) and Ansel Adams.

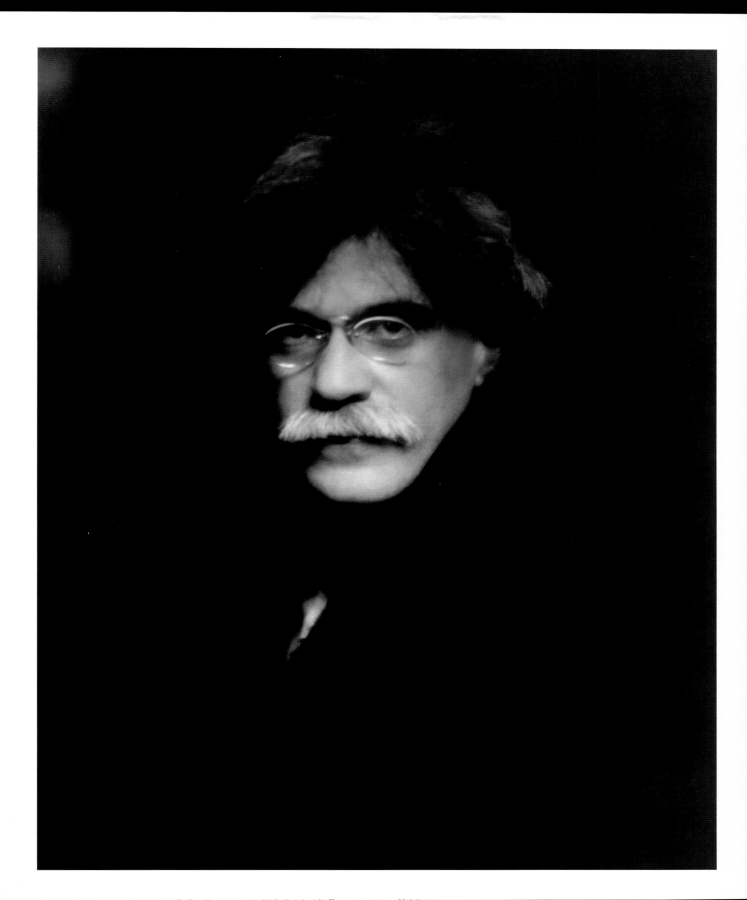

21	1907	Snapshot From My Window, New York.

Berlin was a formative influence on Stieglitz (see no. 18) but New York became his great subject and alternative American locale. The difference between the two urban iconographies is clear, but the New York image is ambivalent in its meaning. In Berlin Stieglitz photographed an established and traditional city; in this image he photographs a new city made momentarily magical by the snow and mist.

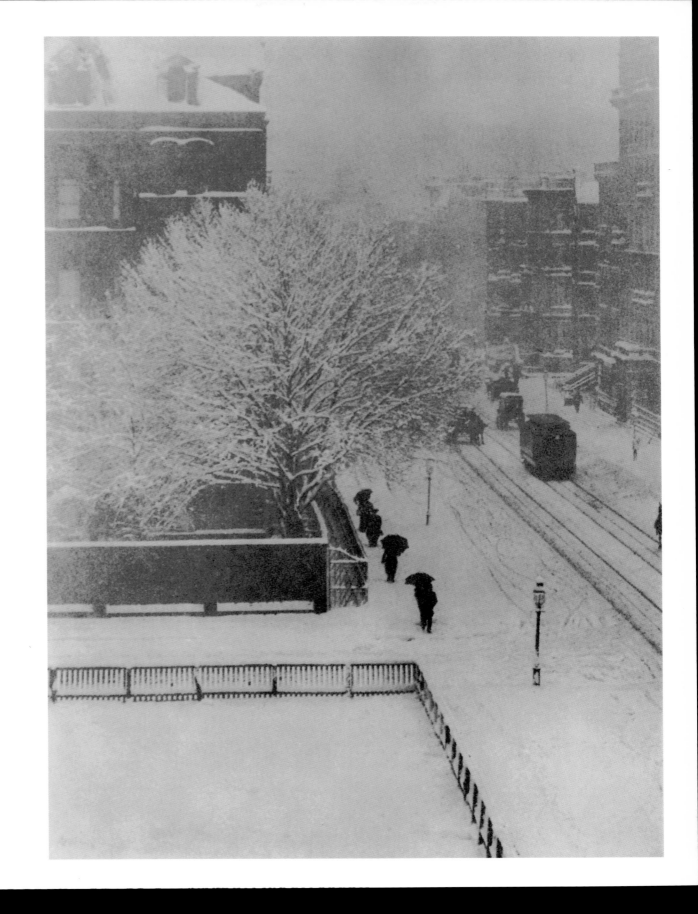

1910 The City of Ambition.

One of a series of long shots of New York to which Stieglitz turned in the mid-1900s. Although a depiction of the 'new' skyscrapers, the title has an ironic undertone, for the image concentrates on the financial district of the city. The material presence of the skyline is balanced by the space given to both water and sky. Stieglitz's aesthetic ambition, as it were, is contrasted with the underlying ambitions of the city, once again showing the difference between his spiritual vision and commercial reality.

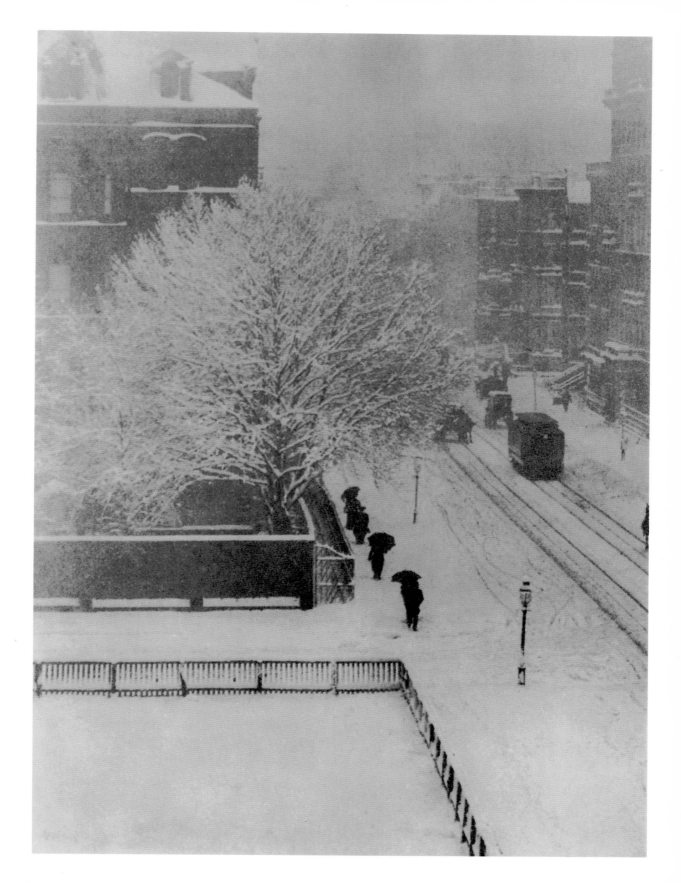

1910 The City of Ambition.

One of a series of long shots of New York to which Stieglitz turned in the mid-1900s. Although a depiction of the 'new' skyscrapers, the title has an ironic undertone, for the image concentrates on the financial district of the city. The material presence of the skyline is balanced by the space given to both water and sky. Stieglitz's aesthetic ambition, as it were, is contrasted with the underlying ambitions of the city, once again showing the difference between his spiritual vision and commercial reality.

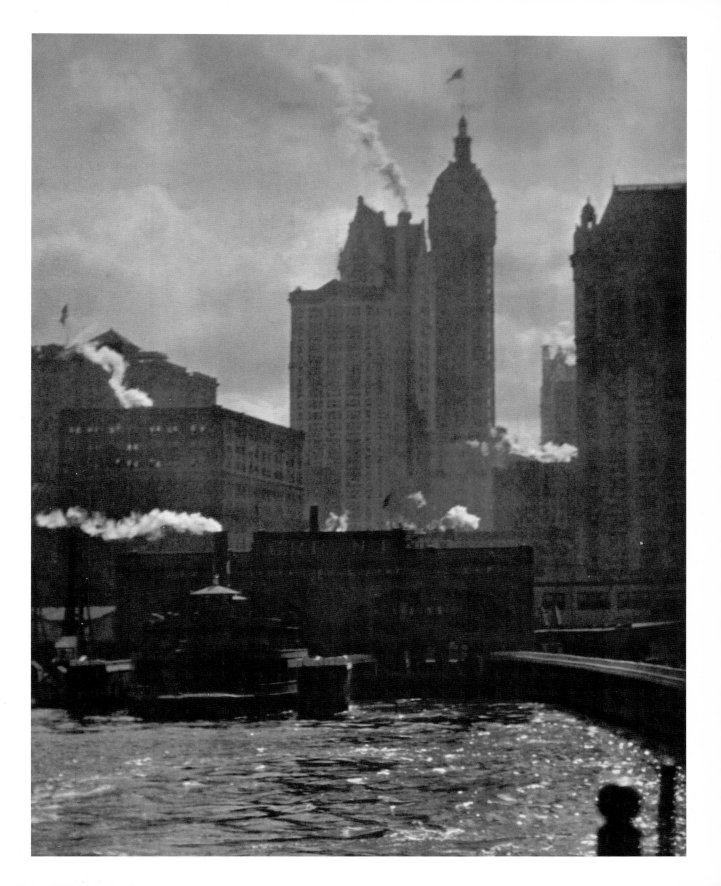

23 1910 The City Across the River.

A view of Manhattan from the Brooklyn side of the East River which, with its focus on the pier for the Fulton Street Ferry, implies both a sense of energy and anticipation as one eyes the skyline of the city. The foreground is given especial significance, contrasting the wood and water with the stone and steel of the city. There is a clear symbolic resonance of Walt Whitman's famous poem (and celebration) of New York: 'Crossing Brooklyn Ferry'.

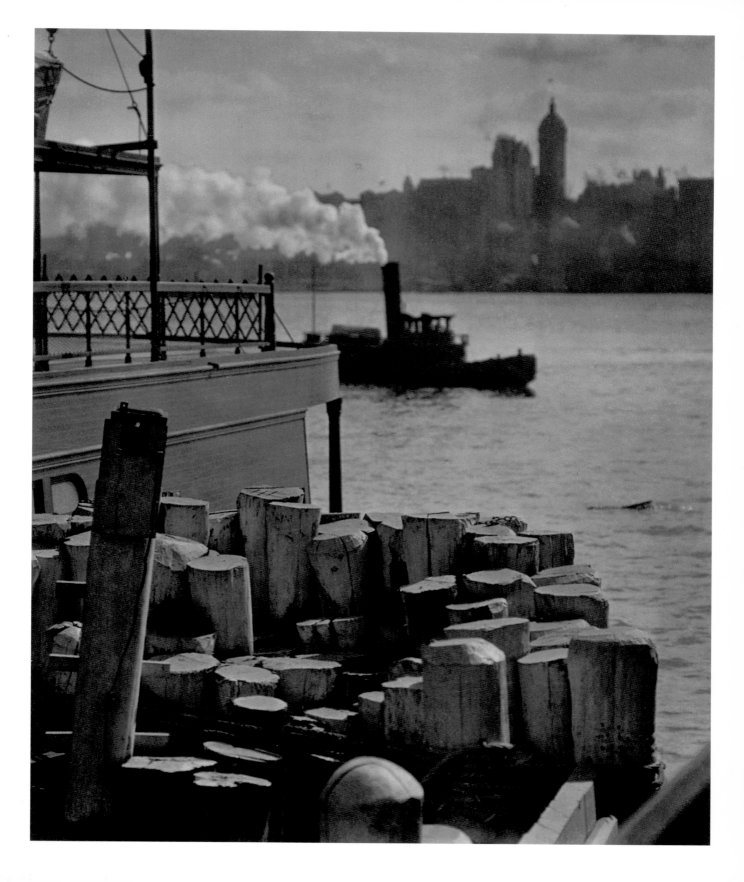

24 1910 Old and New New York.

A street scene which directs the eye upwards to the rapidly changing skyline of New York in the 1900s. Although based on a seemingly single point of contrast between old and new, the image challenges the eye as to how the city is to be read and understood. The figure on the right is surrounded by conflicting energies and offers a second point of reference as to the meaning and perspective of the image.

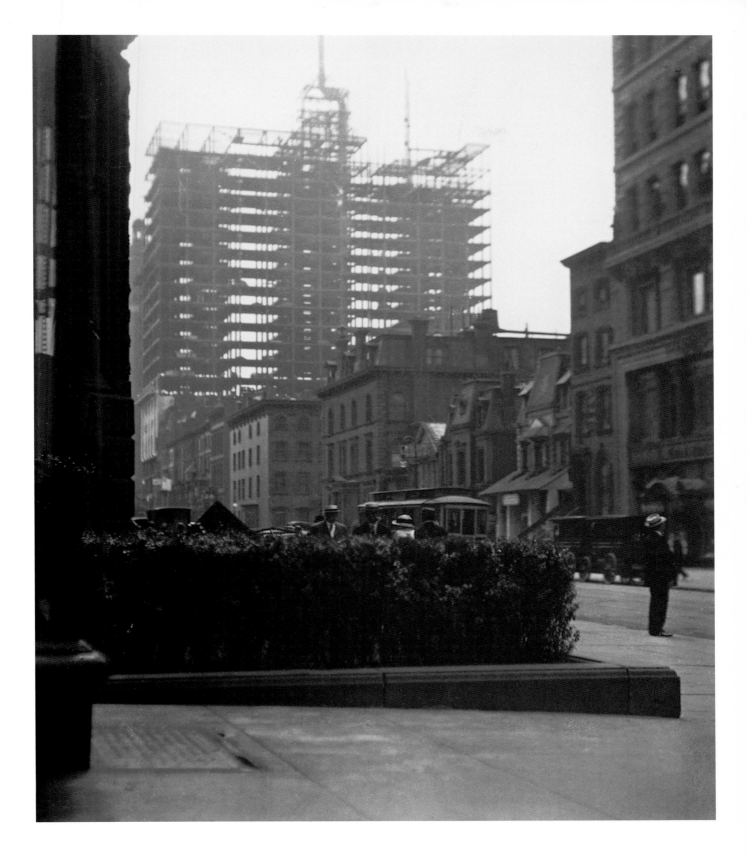

1910 A Dirigible.

Stieglitz's image of an airship reflects his concern with the new and the
modern, akin to his interest in painting and, of course, in photography
as a new technological art form. The image, perhaps, predicts his increasing
concern with looking upwards – to the sky.

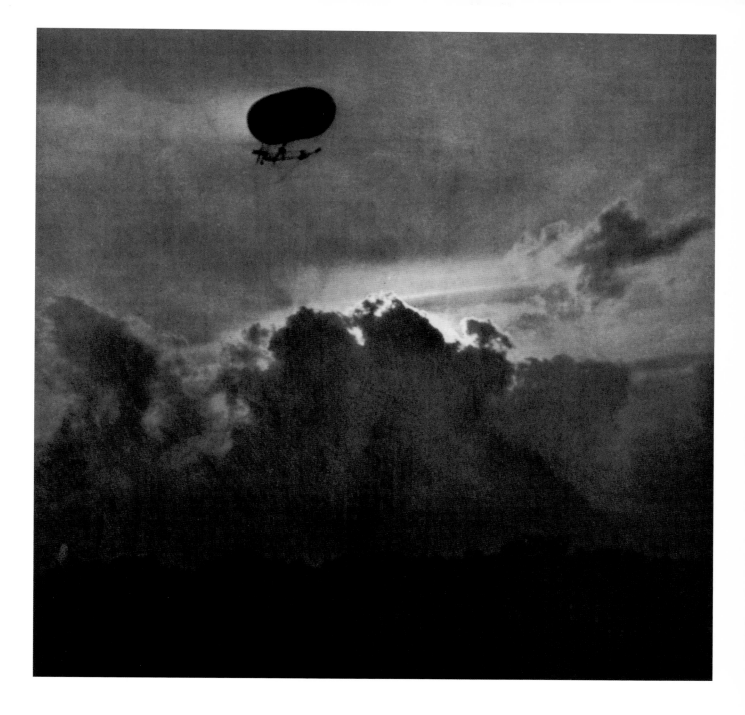

26 1910 | The Pool, Deal.

Published in *Camera Work* in 1911, this image has a wonderfully enigmatic quality about it. Although in its composition it employs the usual balance between geometric elements (in this case a series of diagonals), the scene is peculiarly static. The scene is still where one might expect movement and a celebration of energy. There is an empty, even eerie quality about it which looks towards much American photography of the 1950s and 1960s, for example, the work of Garry Winogrand and Harry Callahan.

27 1911 A Snapshot, Paris.

The casual nature of the title belies its context. In 1911 Stieglitz made his last trip to Europe, but it was also on that trip that he met Rodin, Matisse and Picasso. Although taken on the Left Bank, Stieglitz's 'snapshot' records a nineteenth-century rather than a 'modern' Paris.

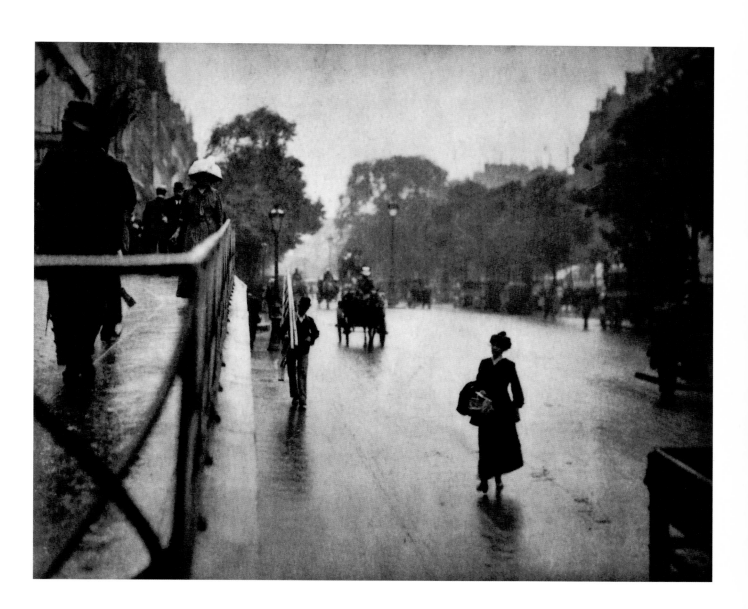

28 1911 Two Towers.

An image taken close to the 291 gallery, this looks towards Madison Square.
The tower on the left is the (now demolished) Madison Square Garden
and on the right the Metropolitan Life Insurance building. The delicate
natural imagery of the foreground contrasts ironically with the commercial
materiality of the city in the background.

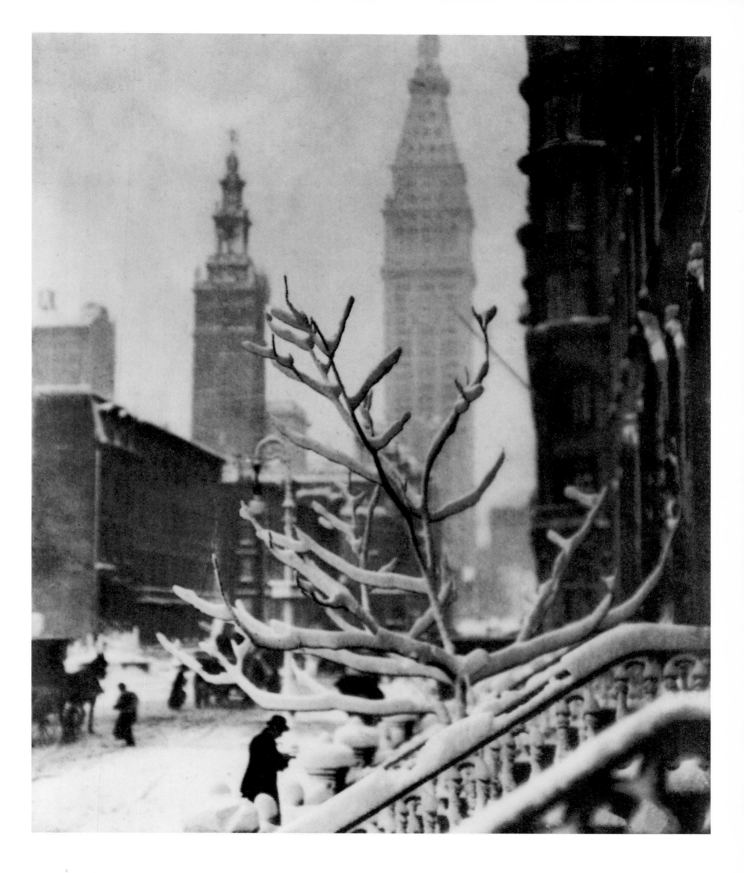

29 1911/12 | Arthur G. Dove.

One of a number of portraits made of the Stieglitz group of painters,
all associated with the new art he proclaimed. Dove (1880–1946) sought
a similar aesthetic to Stieglitz's in his abstract paintings. As Dove declared,
'You get to the point where you can feel a certain sensation of light.' Where
Stieglitz sought 'equivalents', so Dove referred to his paintings as 'extractions'.
The portrait is radical in its approach to the subject. Dove is displaced from
the centre of the photographic space and the camera probes the individual
self. He is not identified as an artist or painter but as a unique identity.

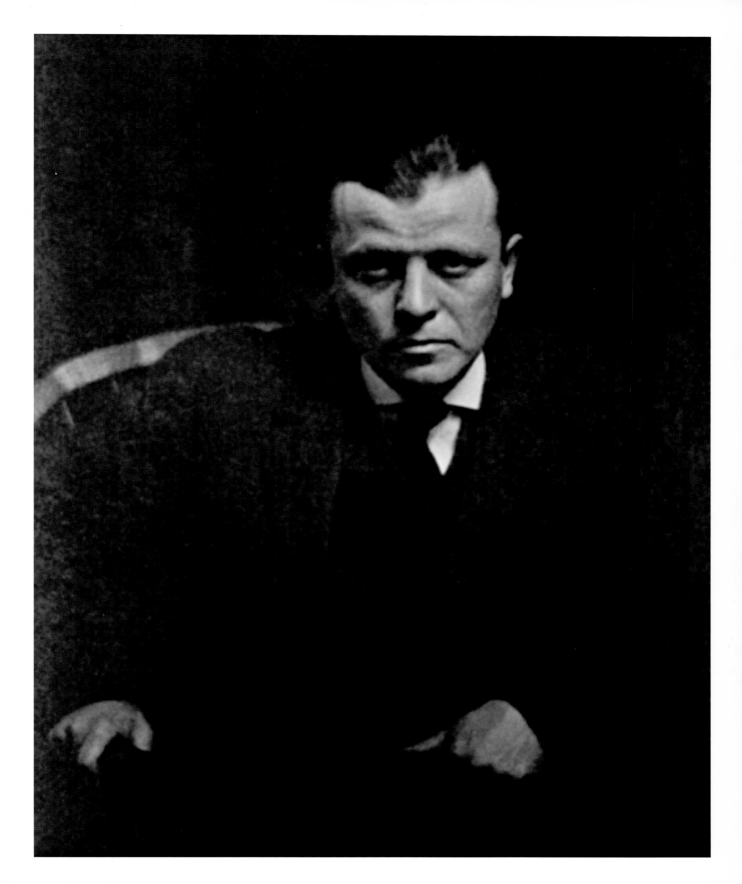

30 1916 | From the Back Window, 291 (Building in Construction).

One of the images Stieglitz took from the fifth-floor back window at 291.
As he wrote in a letter of 1916: 'The window at 291 was quite marvelous
tonight as I looked out – it seemed so restful out there – the buildings all
lit up looming in the mist – and below my own window – rooftops of
neighbouring houses.'

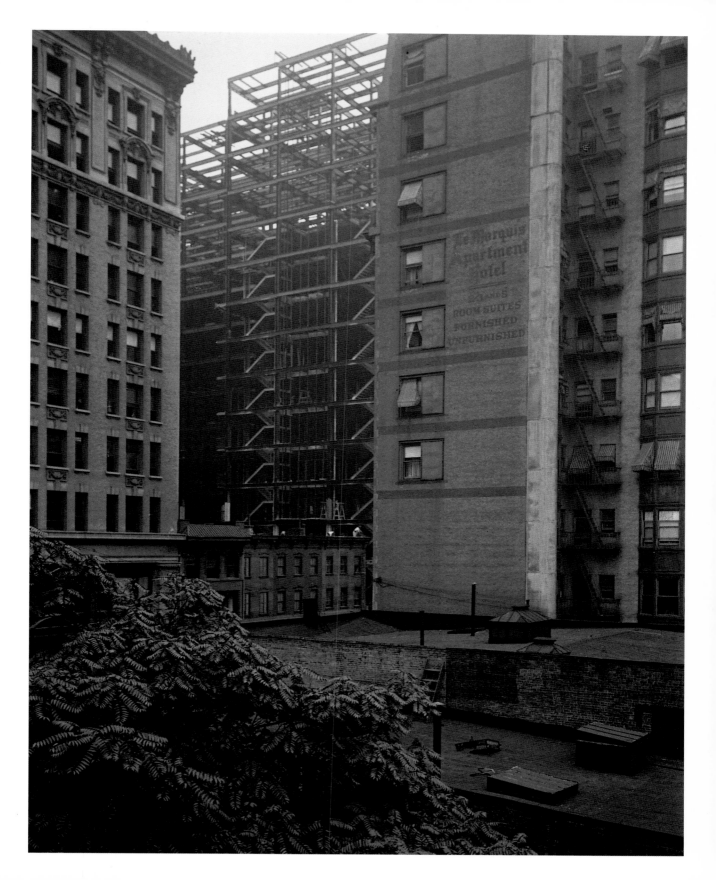

31 1916 Shadows on the Lake.

A radical image which looks towards much later modernist and post-modernist photography, especially in its focus on the 'shadow'. Its ambiguous and problematic effect, however, is balanced by the brilliant use of light to produce a photograph in which there is no material dimension – only process and reflection. It is, in many ways, an exemplary Stieglitz image on the nature of photography: a visual essay.

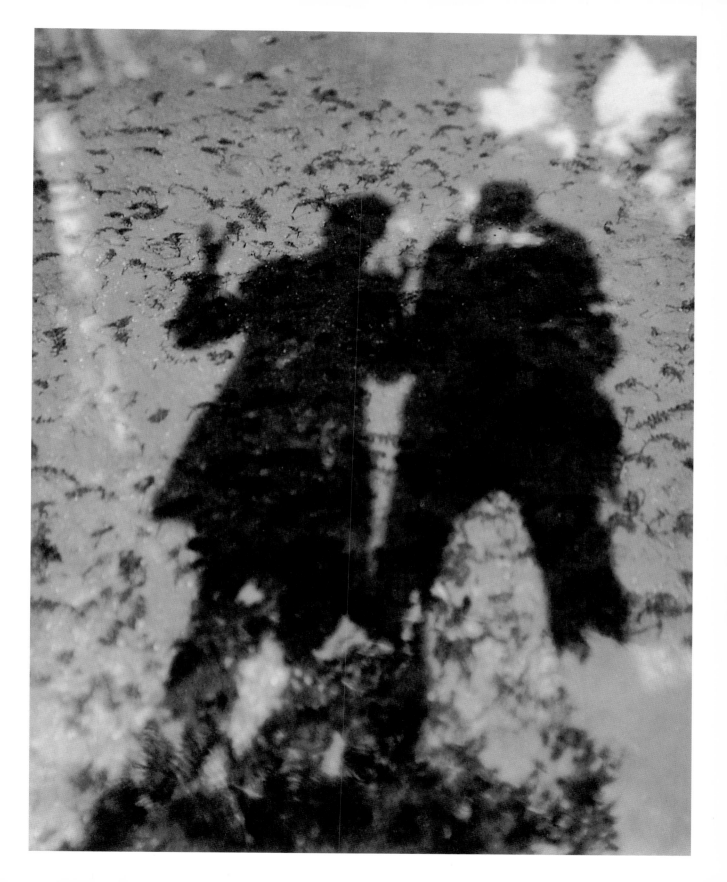

32 1918 | Georgia O'Keeffe.

Stieglitz photographed Georgia O'Keeffe, his second wife, consistently between 1917 and 1937, but no one image can be considered as definitive. Indeed, they must be viewed as part of an ongoing process. What emerges is a complex and often problematic 'body' of material on the nature of portrait photography. This, an early image, has overtones of traditional photographs of women, but O'Keeffe confronts the camera directly while the position of her hands suggests the way in which she protects her body and her self from exposure by the camera.

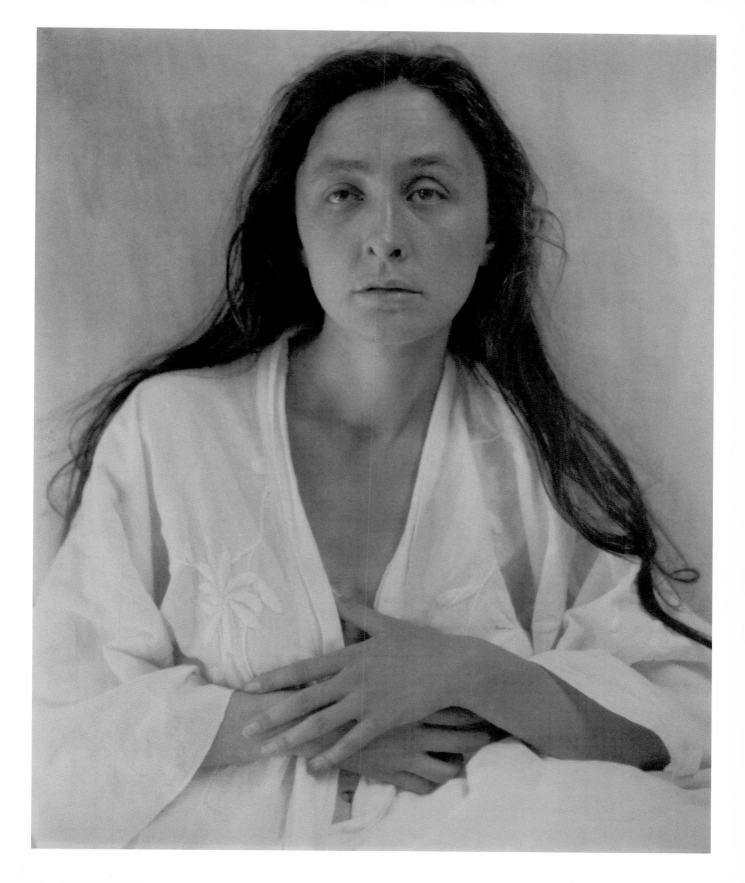

33 1919 Georgia O'Keeffe.

One of a series of nude photographs of O'Keeffe, but its approach to her
body is characteristic. As part of Stieglitz's ongoing attempt to define her,
here he isolates the torso as part of a larger concern with composition and
the body as distinct from the personality as subject. As his friend, Paul
Rosenfeld wrote, Stieglitz made photographs of O'Keeffe 'based ... on faces
and hands and backs of heads, on feet naked and feet stockinged and shod,
on breasts and torsos, thighs and buttocks. He has based them on the navel,
the mons veneris, the armpits, the bones underneath the skin of the neck
and collar.'

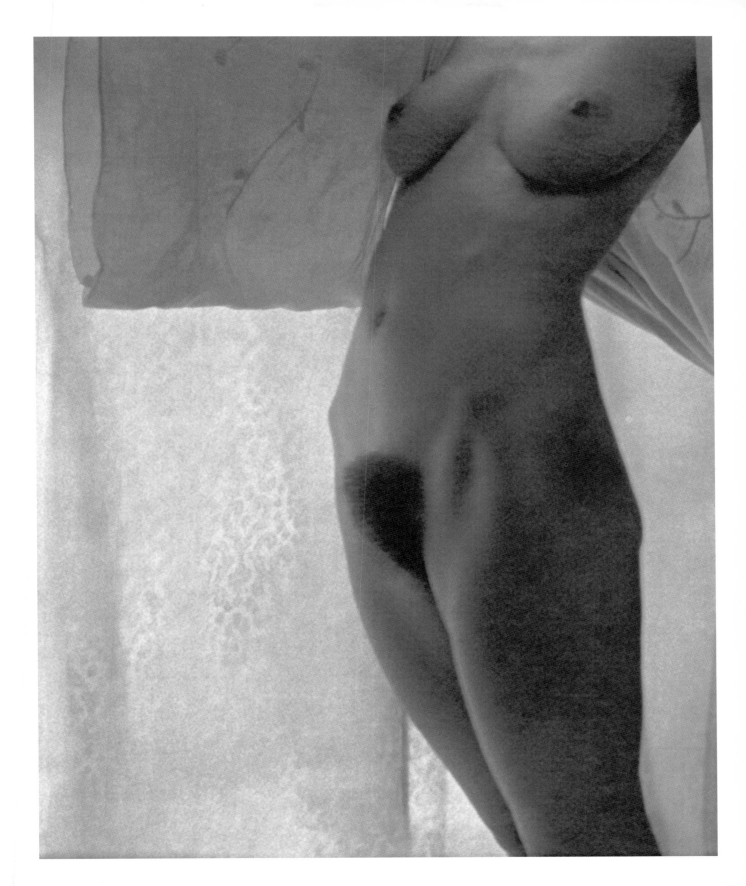

| 34 | 1919 | Georgia O'Keeffe. |

A photograph of O'Keeffe very much in contrast to no. 32. In this image O'Keeffe is austere, emotionless and distant. In addition her identity as a 'woman' is made ambivalent by the cloak that she wears (which Stieglitz also wore), her scraped-back hair and her face devoid of make-up. She is her own person, and escapes any stereotypical impression of her as 'female'. Her gaze dominates the image and looks defiantly at the camera, at Stieglitz and, inevitably, at anyone who views the photograph. The image retains a fervent sense of independence and singularity.

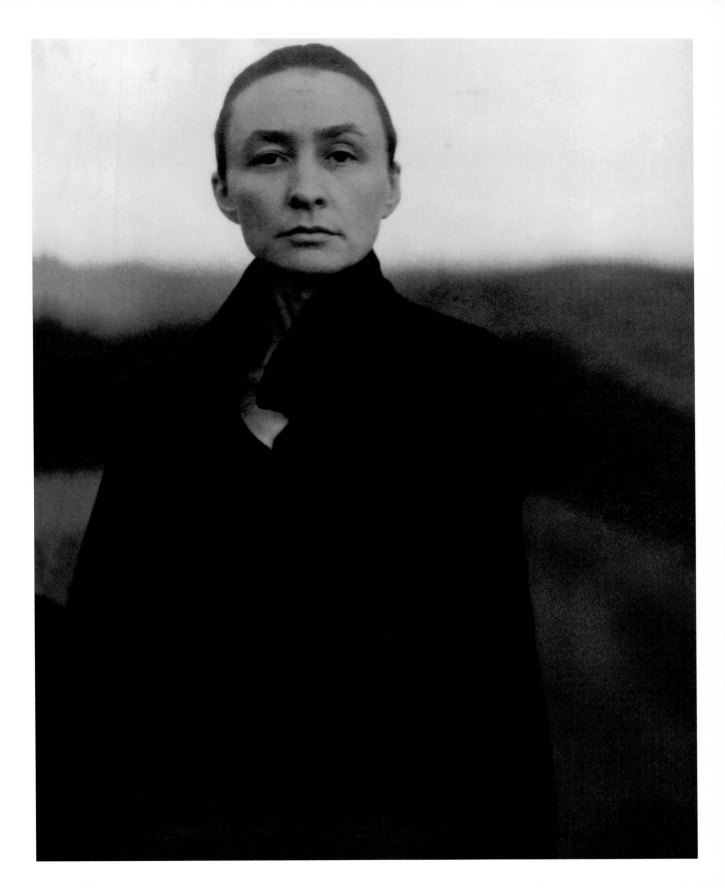

35 1919 | Dorothy True.

Dorothy True was an ex-classmate of Georgia O'Keeffe's, and Stieglitz exhibited this image at the Anderson Galleries in 1921. It is based on a rare mistake by Stieglitz: an accidental double exposure which shows the subject's face and leg simultaneously, producing what is often regarded as one of Stieglitz's few Surrealist images, akin to the work of Man Ray.

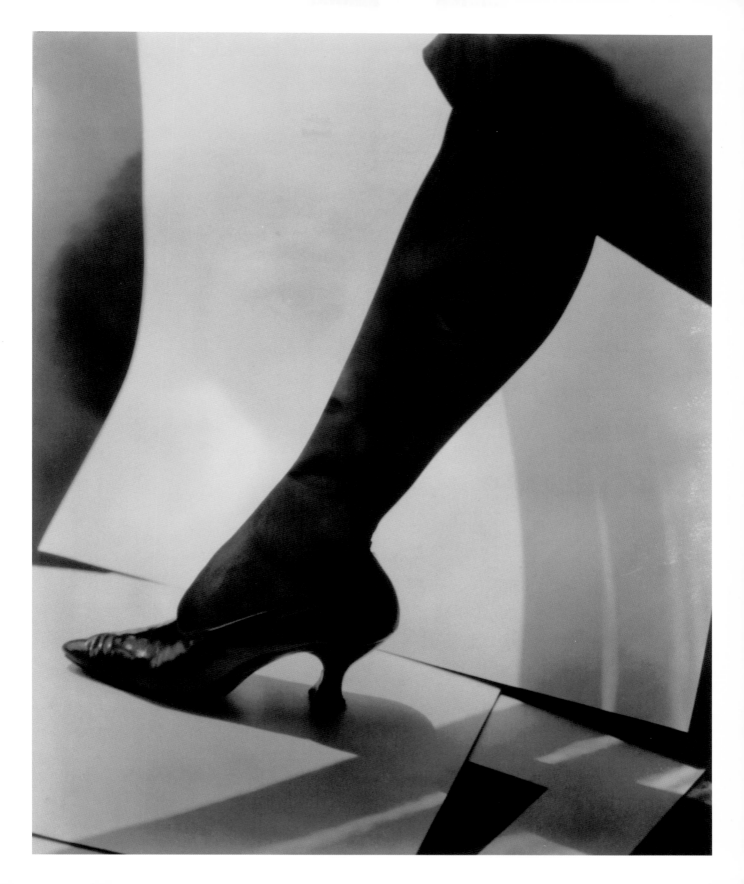

36 1919 | Georgia O'Keeffe, Hands and Thimble.

A delicate image which continues the composite portrait of his second wife. The overall effect of the composition is punctured by the thimble on one of O'Keeffe's fingers, with its overtones of domesticity and sewing. O'Keeffe's hands have a balletic rhythm about them and reflect her painting and its own creative ethos as part of an independent spirit. These hands paint, they do not sew.

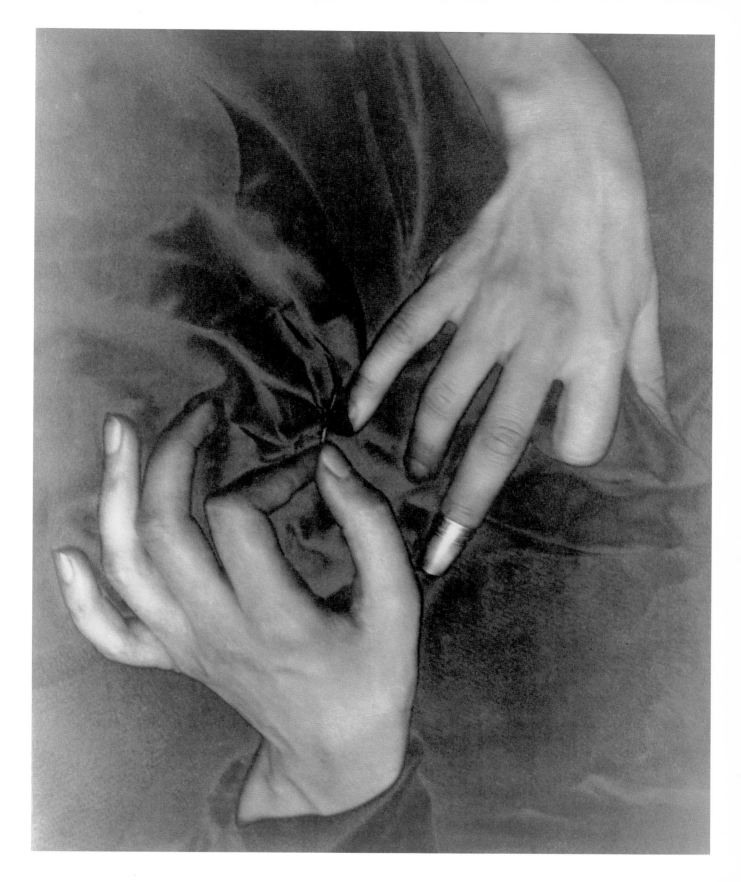

37 1922 Dancing Trees.

A photograph taken at Stieglitz's 'retreat' at Lake George, the title reflects the animated sense of the natural world that he brought to his images and feeling about life. The vibrant quality of the image is enforced by the use of texture and the geometry of the composition, suggestive of a semi-abstract use of form so characteristic of his work as a whole.

38 1922 | At Lake George, Apples in Front of House.

An image from Lake George which suggests parallels with the work of Paul Strand. The prosaic title belies the effect of the photograph based, as it is, on a tantalizing series of tensions between the abstract and literal. As the poet Hart Crane declared of Stieglitz's work, 'That's it. You've captured life.'

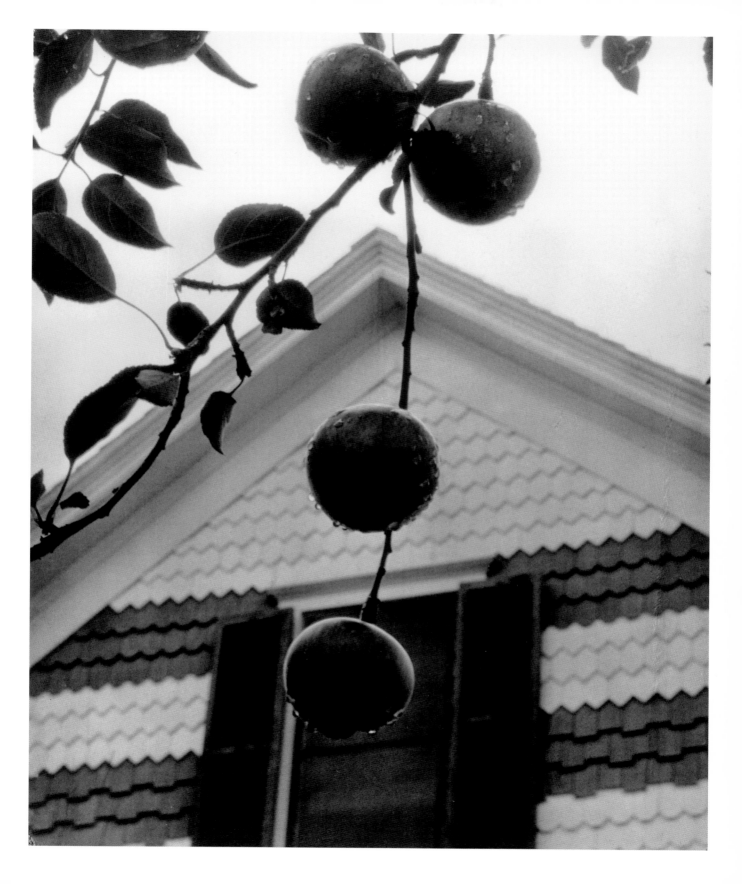

1922 Music, A Sequence of Ten Cloud Photographs, No. 1.

An example of what Stieglitz called 'an experience of spirit', and very much related to the photographs that he took at Lake George in the early 1920s. As he wrote in a letter of 1925 to Sherwood Anderson: 'I have been looking for years – fifty upwards – at a particular skyline of simple hills – how can I tell the world in words what that line is – changing as it does every moment. I'd love to get down what "that" line has done for me – maybe I have – somewhat – in those snapshots I've been doing the last few years.'

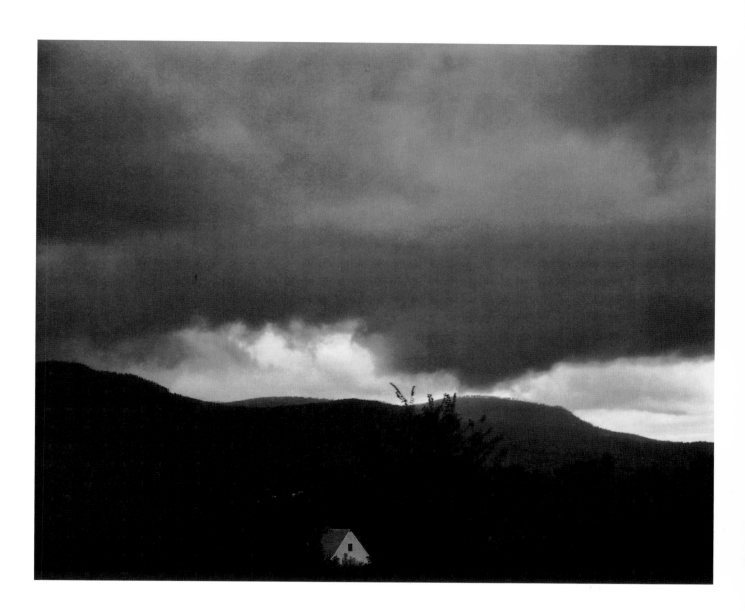

| 40 | 1922/23 | Rebecca Strand. |

Rebecca Strand was the (recently married) wife of the American photographer, Paul Strand. At the time of this photograph she was staying with Stieglitz and O'Keeffe at Lake George. Stieglitz took a number of images of her and later wrote that she was 'a much more pliant and vital model than the … rather fragile O'Keeffe.' Rebecca Strand's torso is seen through the clear waters of Lake George.

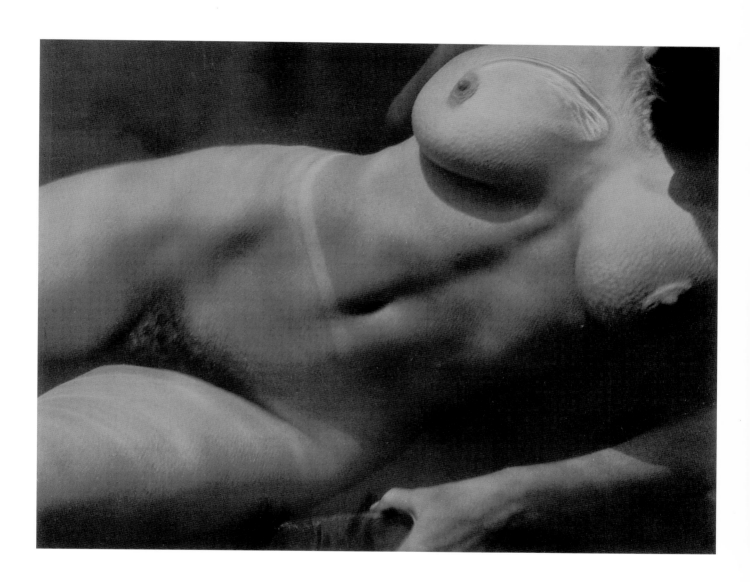

41 1923 | Spiritual America.

Stieglitz consistently sought confirmation of a 'spiritual' America, but the ironic title of this image reflects his increasing pessimism with and isolation from the United States. The gelded stallion is suggestive of the way in which, for Stieglitz, America's potential and creative energy had given way to a sterile, material and commercial culture. The harness implies a restrictive and limiting condition which restrains the power and freedom of the horse. An iconic image which underlies Stieglitz's relation to America throughout his life.

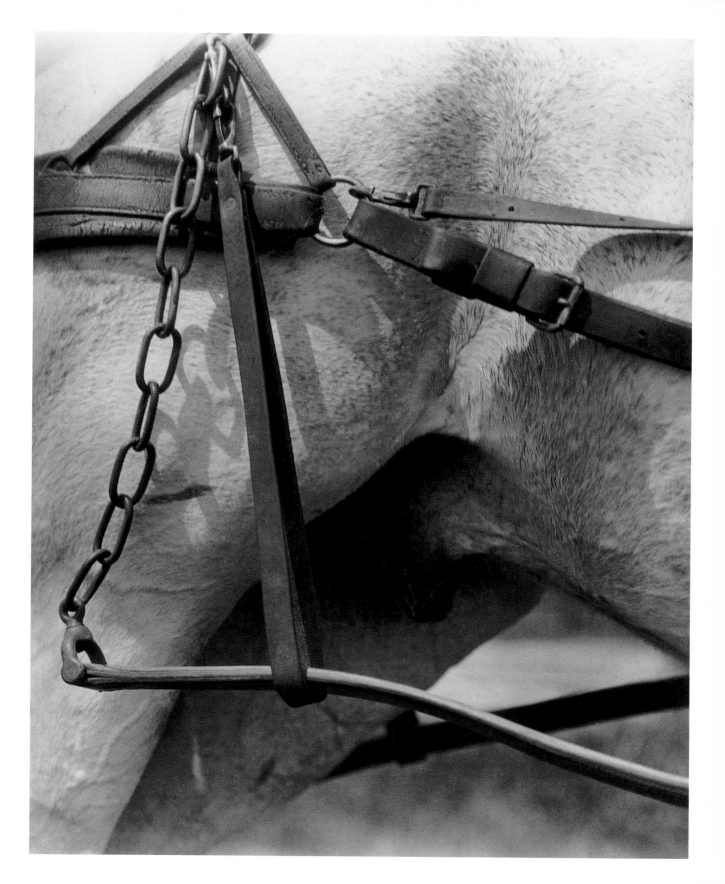

42 1923 First Snow and the Little House.

A visual poem which achieves a lyrical intensity as both a celebration of
the atmosphere and the moment. The response to the scene is suggested in
a letter Stieglitz wrote that same year: 'On Sunday we had a day of days –
a blizzard – snow knee high. And you should have seen how we enjoyed it.
All day out of doors. I photographing like possessed. O'Keeffe wandering
about in the woods – & rushing down to the lake – All awonder … Beauty
everywhere – Nothing but Beauty … White – White – White – & soft &
clean – & maddening shapes – the whole world in them.'

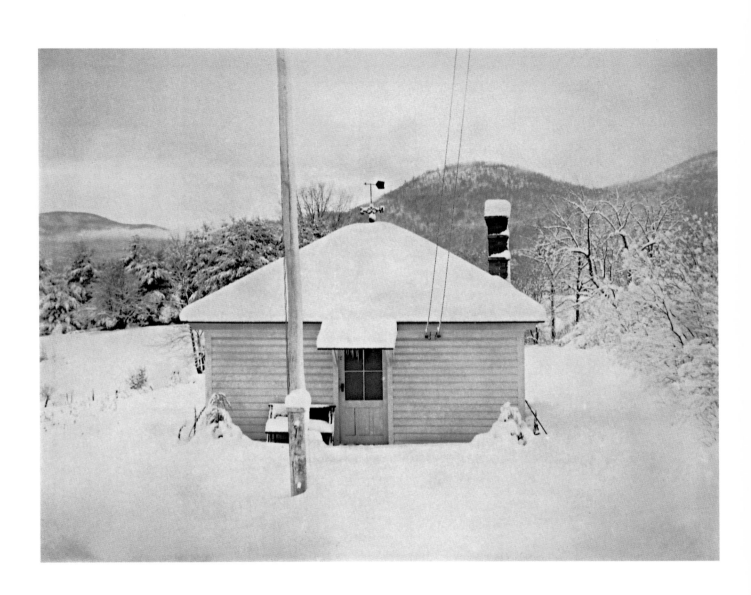

43 1923 Barn and Snow, Lake George.

A gelatin silver print which lays stress on the contrast between black and white and their relation to the geometry of the scene. Once again, the 'shapes' Stieglitz saw in *The Steerage* (no. 19) dominate his response to a personal scene full of memory and history.

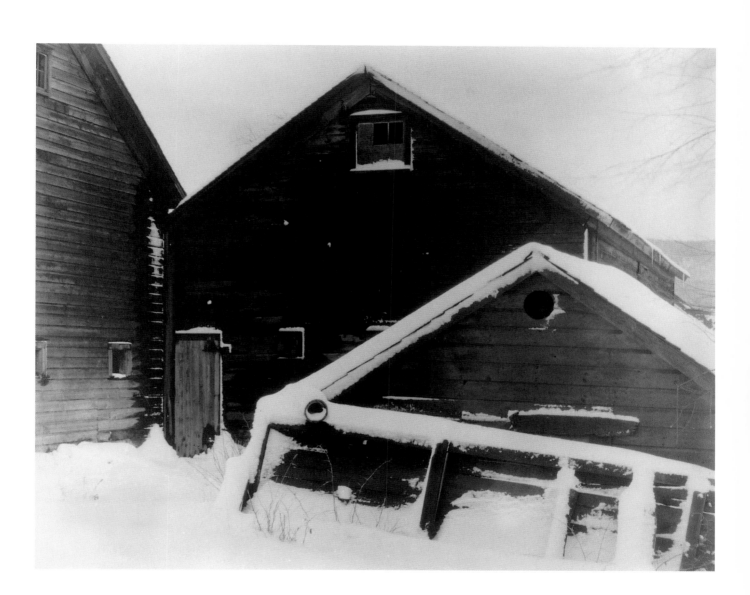

44 1923 Songs of the Sky, No. 3.

An exemplary image which should be considered in relation to what Dorothy Norman said about Stieglitz's feeling for a scene. As she wrote, 'He saw, and felt, the most fleeting moments of the most fragile and angelic delicacy, perfectly merged with the most deep-rooted, eternal, timeless surges of man's relationship with all things in the universe.'

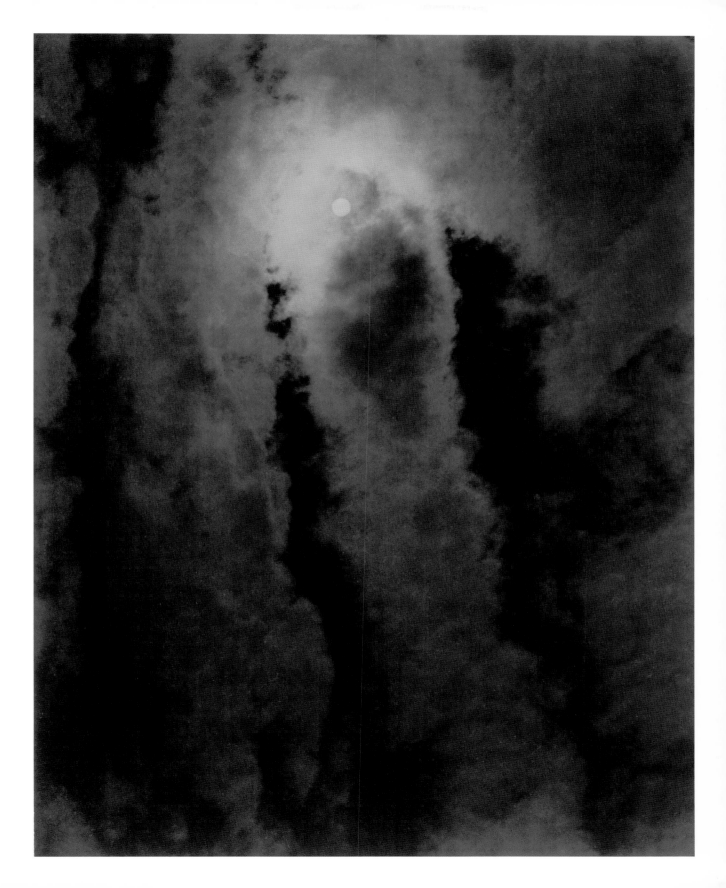

45 1926 Equivalent.

The approach by Stieglitz to the photograph here was suggested by the
American photographer, Ansel Adams, when he declared that an *Equivalent*
was an example of 'The image which bears no descriptive title and bears no
dominating literal significance – and is, perhaps, his greatest contribution,
and is supremely important to the progress of creative photography.'

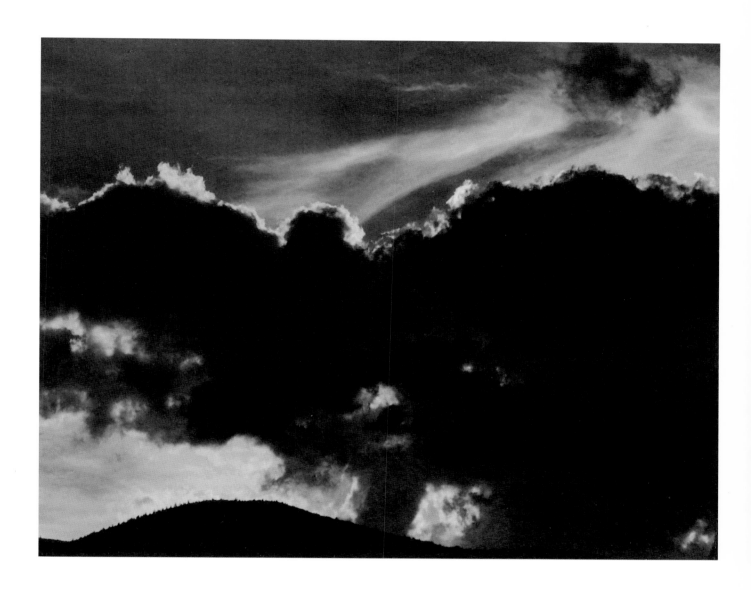

46 1927 | Equivalent.

One of the most abstract of the *Equivalents*, this image confronts the eye with a sense of mysterious energy. Any notion of the objective and three-dimensional has given way to an achieved 'otherness'. As Stieglitz declared: 'In reality all my photographs are *Equivalents*.'

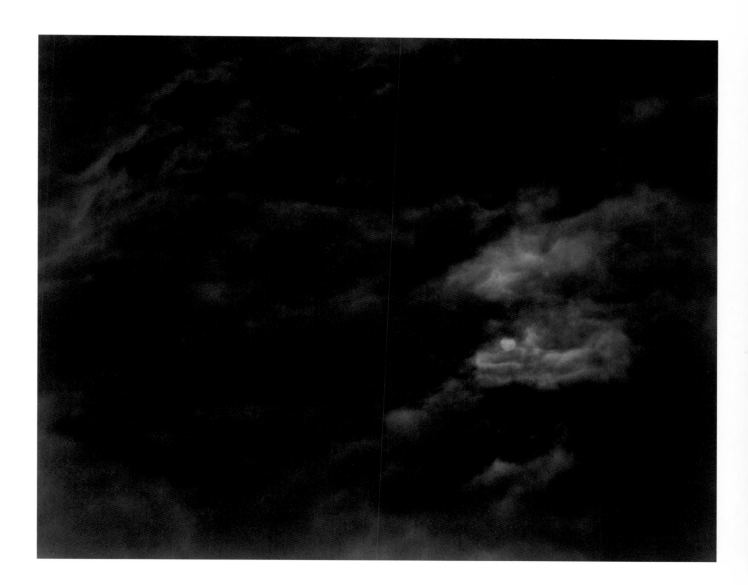

An image which reflects both Stieglitz's philosophy and his technical brilliance, especially in relation to the actual photograph as a work of art. As he wrote in 1942: 'You seem to assume that a photograph is one of a dozen or a hundred or maybe a million – all prints from one negative necessarily being alike and so replaceable. But then along comes one print that really embodies something that you have to say is subtle and elusive, something that is still a straight print, but when shown with a thousand mechanically made prints has something the others don't have. What is it that this print has? It is certainly not something based on a trick. It is something born out of spirit, and spirit is an intangible while the mechanical is tangible.' The general title belies the unique quality Stieglitz sought in each of his photographic prints. Its approach looks back to the work of P. H. Emerson and forward to Harry Callahan.

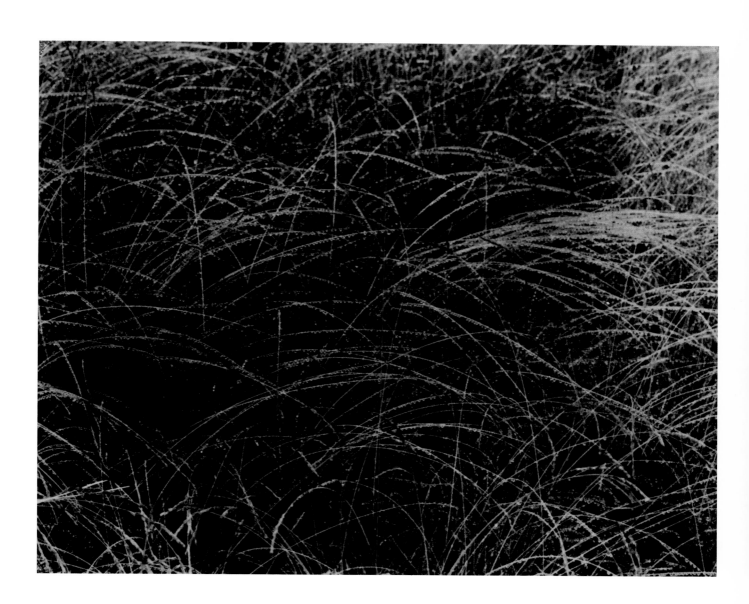

48 1930 New York.

An image (taken from Stieglitz's gallery, An American Place) of mid-town Manhattan to be viewed in relation to what he said in 1920: 'My New York is the New York of transition – The Old gradually passing into the New ... Not the 'Canyons' but the spirit of that something that endears New York to one who really loves it – not for its outer attractions – but for its deepest worth and significance – The universal thing in it.'

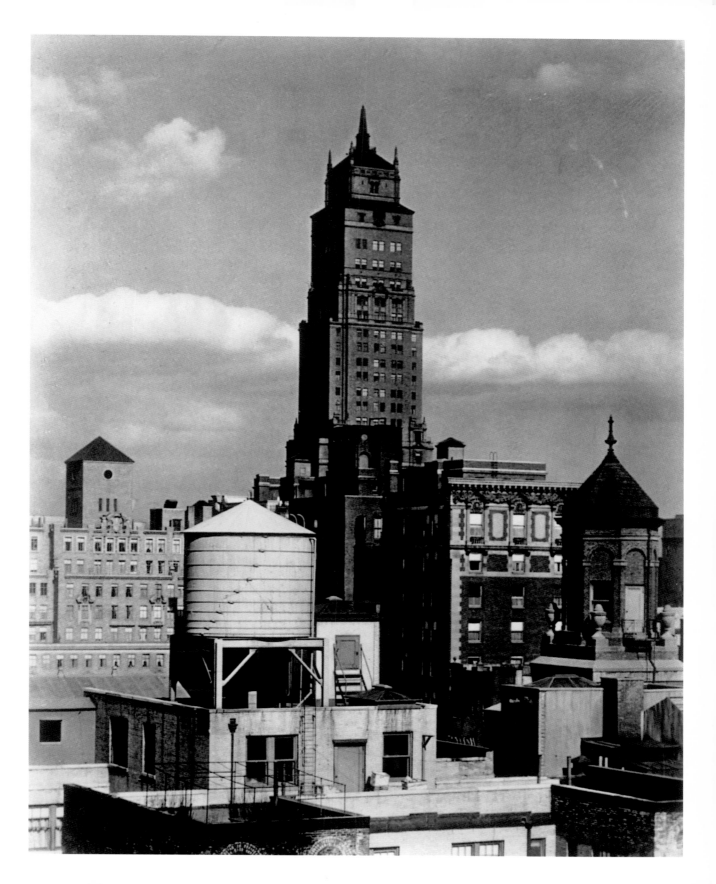

49 1931 From My Window at An American Place, North.

In 1930 Stieglitz wrote in a letter that 'I'm upon the seventeenth floor of
a new skyscraper – The place is bare – nothing like it. Nothing nouveau
– nothing arty – just direct and the city outside is wonderful.' This sense
of the 'wonderful' is reflected in this image. Its combination of light and
shadow, of textures and patterns, and the inferences of construction create
a rare sense of optimism for the period. But this *is* taken from An American
Place, Stieglitz's sanctuary and place of safety.

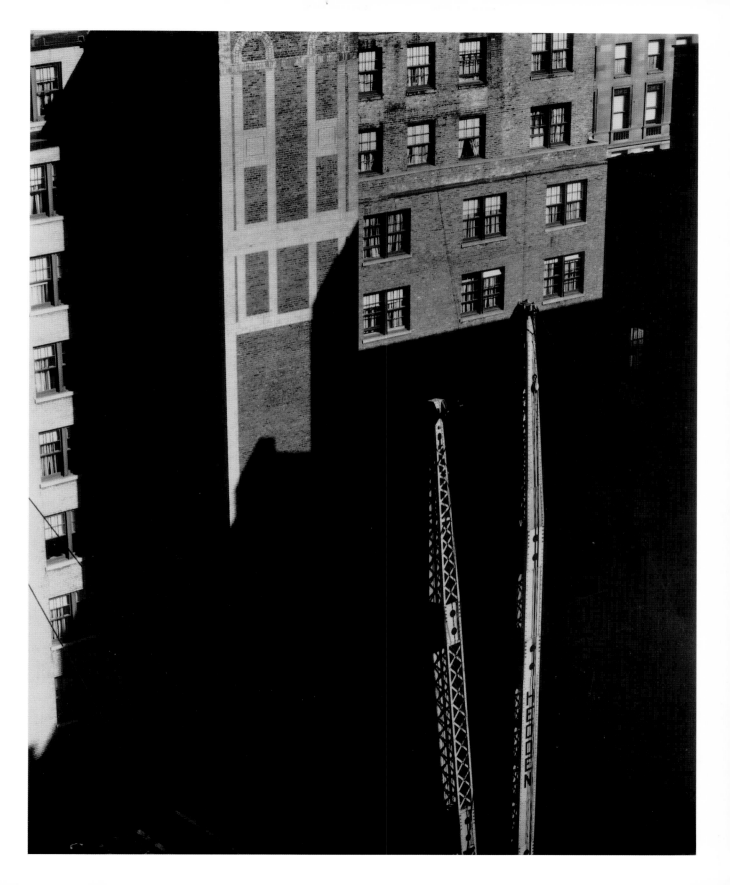

50 1931 | From My Window at the Shelton, West.

In the 1930s Stieglitz started to photograph New York either from
An American Place or the Shelton Hotel. This is a typical example of his
views of mid-town Manhattan. In the background is Rockefeller Center
under construction which contrasts with the twin spires of St Patrick's
Cathedral to its right. The building on the immediate right is the Waldorf
Hotel, completed but not yet open and, significantly, empty. The scene,
although full of images of construction and change, contains no human figures.
In 1925 Stieglitz had written that he and O'Keeffe 'live high up in the Shelton
Hotel … All is so quiet except the wind … it's a wonderful place.'

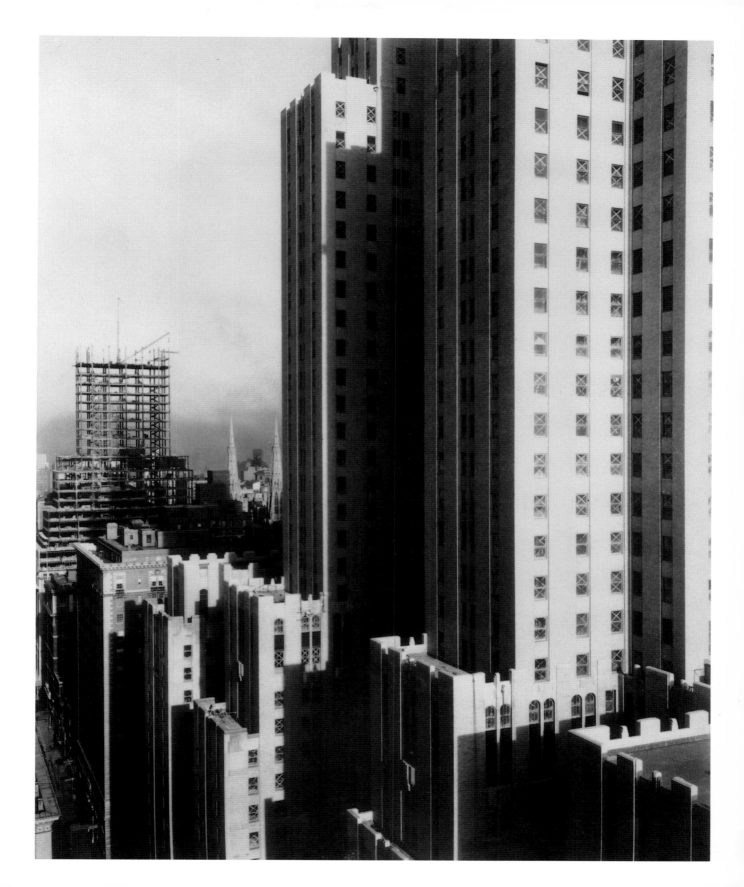

51 1932 From My Window at An American Place, Southwest.

From the 1930s Stieglitz photographed New York only from behind
windows and increasingly from high above the city. Another view from
his seventeenth-floor gallery, this has a melancholic and empty feel about
it which was to become so characteristic of the images he took from the
Shelton Hotel. Once again, an image of construction and change is 'framed'
within an overwhelming presence of darkness and gloom.

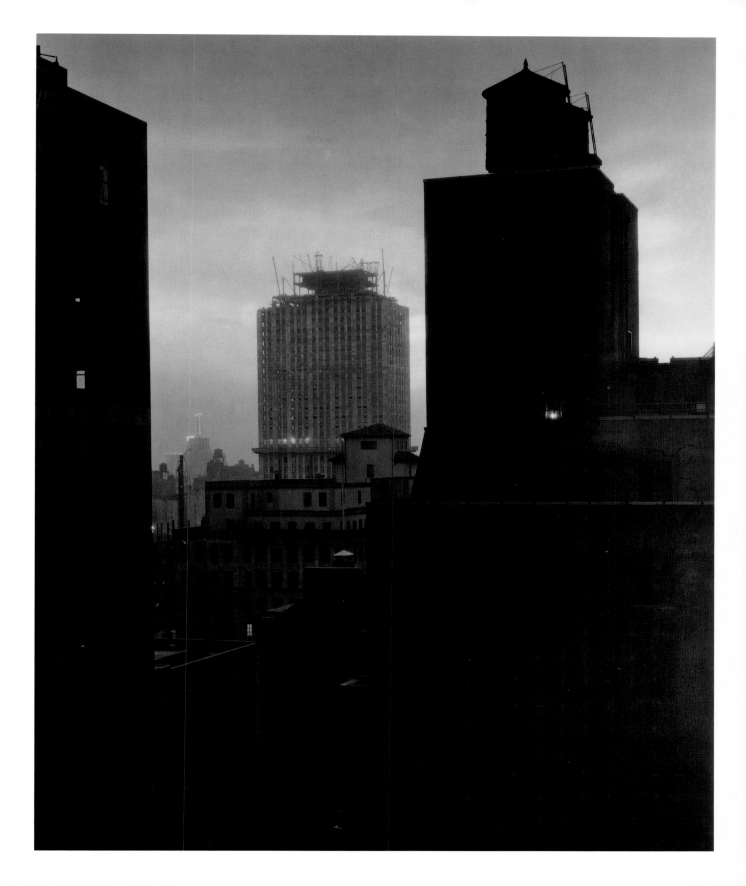

52 | Early 1930s | Portrait of Richard Muncheusen, Lake George.

This image overwhelms the eye not so much by the presence of the subject portrayed as by the way the figure is related to the structure of the photograph and its use of contrast between light and dark. It is both tantalizingly complex and subtle in its approach, just as it is disarmingly assured in its composition. The figure is placed within a balanced photographic space that both highlights specific details (the hat, the braces) and makes them part of a unity that refuses to be paraphrased. The nuances implicit in the image might be compared with similar figures photographed by Walker Evans and Dorothea Lange in the same decade.

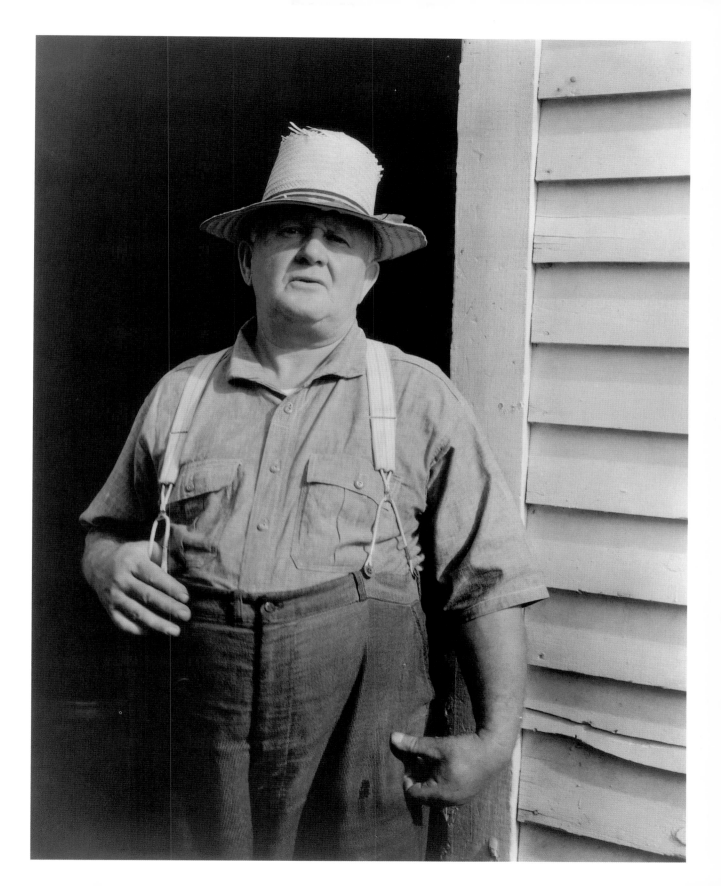

53 1932 | Poplar Trees, Lake George.

A late photograph from Lake George in which Stieglitz transforms the scene into the seen; a visual metamorphosis of the kind he always sought in his photography. The subtle gradations of tone emphasize his constant concern that, in his work, 'there is ... ever an affirmation of light.' It is a significant example of his declaration that the power of his photographs was 'not due to subject matter.'

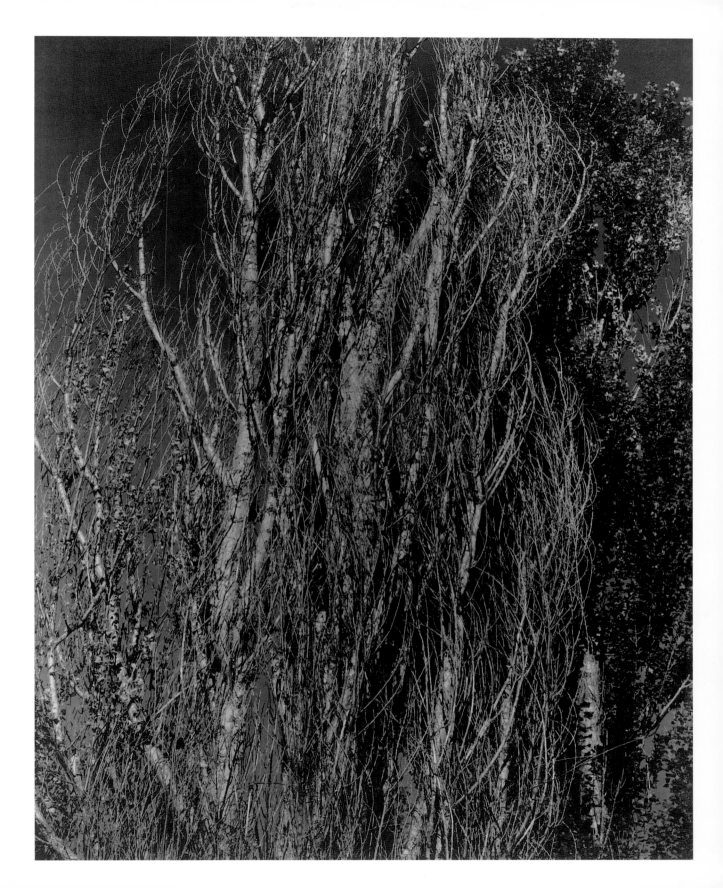

1932 Dorothy Norman XXIV, Hands with Camera.

Stieglitz and Norman had an intimate personal relationship which developed
at the beginning of the 1930s and is reflected in the number of photographs
they took of each other. This image concerns a different aspect of their
relationship. In 1931 he lent Norman a 4 x 5 inch Graflex single lens
reflex camera and encouraged her interests in photography. An established
photographer in her own right, although heavily influenced by Stieglitz's
teaching, this image reflects his philosophy: the balance between the
machine and the hand as a creative element. An example of the relationship
between the human and the technical so basic to Stieglitz's approach.

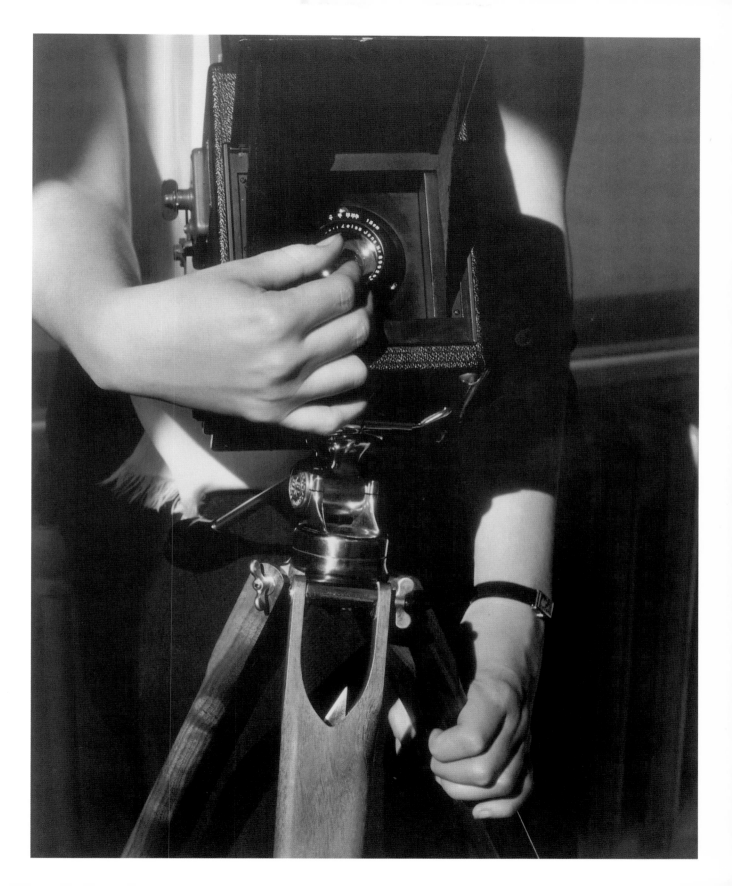

55 1933 Georgia O'Keeffe, Hand and Wheel.

The hand belongs to O'Keeffe but its juxtaposition with the wheel of an automobile raises a series of contrasts and tensions, as much in the symbolic associations of the wheel as a circular figure as the car as a product of modern America. As Hart Crane wrote, 'America is the land of the machine.'

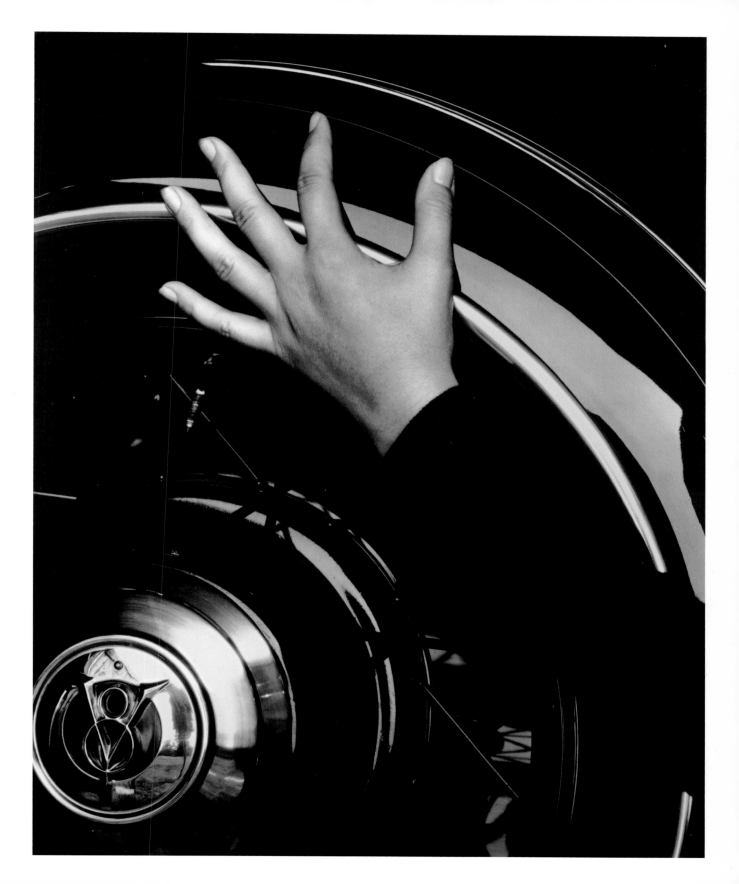

1864	Born 1 January, Hoboken, New Jersey, the eldest of six children.
1871	Family moves to New York.
1871–82	Attends schools in New York and Germany.
1881	Father (Edward) retires and takes family to Europe.
1882–90	Attends Berlin Polytechnic Institute and University of Berlin. Moves from the study of mechanical engineering to photography.
1883	Buys first camera and makes first photographs.
1887	Visits Italy and makes a series of photographs. Awarded photographic prize by *Amateur Photographer* (London). Competition judged by P. H. Emerson.
1888	Articles published on his work by P. H. Emerson and H. W. Vogel. Father buys house ('Oaklawn') at Lake George, New York State.
1889	In Berlin.
1890	Returns to New York. Involved with photo-engraving business.
1891	Joins Society of Amateur Photographers.
1892	First use of hand-held camera for scenes of New York.
1893	Marries Emmeline Obermeyer. Lives at Savoy Hotel, New York. Takes first 'snow' photographs.
1893–96	Involvement with *American Amateur Photographer*.
1894	In Europe: visits Italy, Austria, Germany, Holland, France and England. Elected to 'The Linked Ring', an English photographic group.
1896	Takes first 'night' photographs.
1897	Begins *Camera Notes*. Publishes *Picturesque Bits of New York*.
1899	Retrospective exhibition at Camera Club (New York).
1900	Meets Edward Steichen.
1902	Establishes the 'Photo-Secession' aesthetic.
1903	First edition of *Camera Work* published.

1904	Travels to Europe (and again in 1907, 1909 and 1911).
1905	Opens The Little Galleries of the Photo-Secession at 291, Fifth Avenue, New York (known as '291'). Over eighty exhibitions held between 1905 and 1917.
1907	In Paris, where he sees work by Cézanne and Matisse.
1909	Father dies. Meets Matisse and Leo and Gertrude Stein in Paris.
1911	Meets Picasso and Rodin in Paris.
1913	Own exhibition (50 prints) at 291. Armory Show opens in New York.
1917	291 closes. Last issue of *Camera Work*. First images of Georgia O'Keeffe.
1918	Divorces Emmeline.
1921	Exhibits at the Anderson Galleries, New York.
1923	Begins cloud studies at Lake George.
1924	Marries Georgia O'Keeffe. Both exhibit work at the Anderson Galleries.
1925	Organizes 'Seven Americans' exhibition at the Anderson Galleries. Includes Paul Strand, John Marin, O'Keeffe, Charles Demuth, Marsden Hartley, Arthur Dove and Stieglitz.
1925–29	Operates The Intimate Gallery, Park Avenue, New York.
1925–36	Stieglitz and O'Keeffe live at the Shelton Hotel, New York.
1928	Metropolitan Museum of Art, New York acquires Stieglitz prints.
1929–46	Runs An American Place, Madison Avenue, New York. Holds some 75 exhibitions, including work by Ansel Adams and Eliot Porter.
1932	One-man exhibition at An American Place (127 prints).
1934	*America and Alfred Stieglitz* published (eds Dorothy Norman & Waldo Frank).
1937	Stieglitz stops photographing.
1941	Museum of Modern Art, New York acquires Stieglitz prints.
1946	Dies 13 July, New York.

Phaidon Press Limited
Regent's Wharf
All Saints Street
London N1 9PA

Phaidon Press Inc.
180 Varick Street
New York NY 10014

www.phaidon.com

First published 2006
© 2006 Phaidon Press Limited

ISBN–10: 0 7148 4255 9
ISBN–13: 978 0 7148 4255 4

Designed by Pentagram
Printed in China